The Hidden Peoples of the Amazon

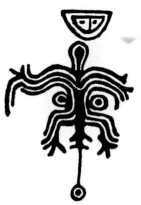

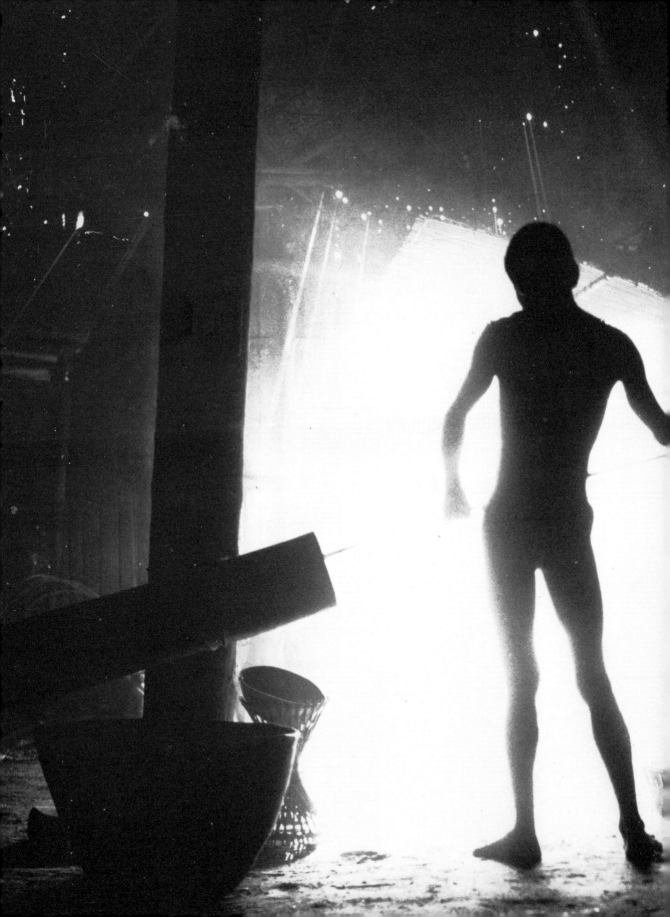

The Hidden Peoples of the Amazon

Elizabeth Carmichael

Stephen Hugh-Jones

Brian Moser
and Donald Tayler

Published for the
Trustees of the British Museum by
British Museum Publications Limited

© 1985 The Trustees of the British Museum

Published by British Museum Publications Ltd
46 Bloomsbury Street, London WC1B 3QQ

British Library Cataloguing in Publication Data
The Hidden peoples of the Amazon.
 1. Indians of South America——Amazon River
 Region (Brazil)——Social life and customs
 I. Carmichael, Elizabeth
 981'.1'00498 F2519.1.A6

 ISBN 0–7141–1573–8

Designed by Harry Green

Set in Monophoto Photina
and printed in Great Britain by
Jolly & Barber Ltd, Rugby, Warwickshire

(*page 1*) Ancient rock carving from the Piraparaná
river, Colombia, probably representing Ní, a river god.

(*pages 2–3*) Makuna man sieving coca-leaf
powder in a wooden mortar.

Contents

A creation myth of the Tukano Indians of the northwest Amazon tells that the first men were sent to earth by the Sun Father, creator of the universe. They travelled in a great Snake-Canoe in the form of an anaconda, a giant aquatic snake common in the rivers of the region. These first men dispersed along the rivers and settled in the forests to people the earth.

Foreword

This booklet accompanies an exhibition which is arranged in two parts. The first part surveys, as completely as the collections in the British Museum allow, the lifestyles of the many Indian peoples of the tropical forest regions of South America. The second part, the reconstruction of a Tukano house (*maloca*) from the Colombian–Brazilian border country of the northwest Amazon, gives a more complete view of the daily life of one particular group of peoples.

The three articles which follow complement the information given in the exhibition itself. The first describes in broadest outline some of the characteristic aspects of the Indian cultures of Amazonia. So much has been written on the subject that it can only be considered the briefest introduction. The bibliography at the end provides suggested further reading.

Much of the material shown in the reconstructed Tukano *maloca* is from a collection made in the early 1960s by Dr Donald Tayler and Mr Brian Moser. It is one of the most complete collections of South American tropical forest material culture in the British Museum. Dr Tayler has provided an introduction to the extract from the account of their travels in Colombia which forms the second article. Originally published as *The Cocaine Eaters* in 1965, and now sadly out of print, it gives a vivid impression of their expedition and adds another dimension to the material in the display as do their many fine photographs.

Some of the other specimens shown in the *maloca* are lent by Drs Christine and Stephen Hugh-Jones, who have been working in the northwest Amazon since 1968. The final article is Dr S. Hugh-Jones' very complete description of Barasana (a Tukanoan tribe) material culture and an introduction to the social context and symbolic significance of the many artefacts of daily life. This is especially useful since it is this very aspect of any culture that is most difficult to present in an exhibition. As he says, much of what he has written may be taken to apply in broad terms to most Amazonian tribes.

It is finally worth adding that some items shown in the *maloca* are from collections made by Dr Richard Spruce, a nineteenth-century botanist who worked in the tropical forest, and which are now in the collections of the British Museum and the Royal Botanic Gardens at Kew. Though some of the items shown are now obsolete, many of them are no different from those collected over one hundred years later, attesting the strong persistence of Amerindian cultural traits which are only now being abandoned as the result of greater contact with the outside world.

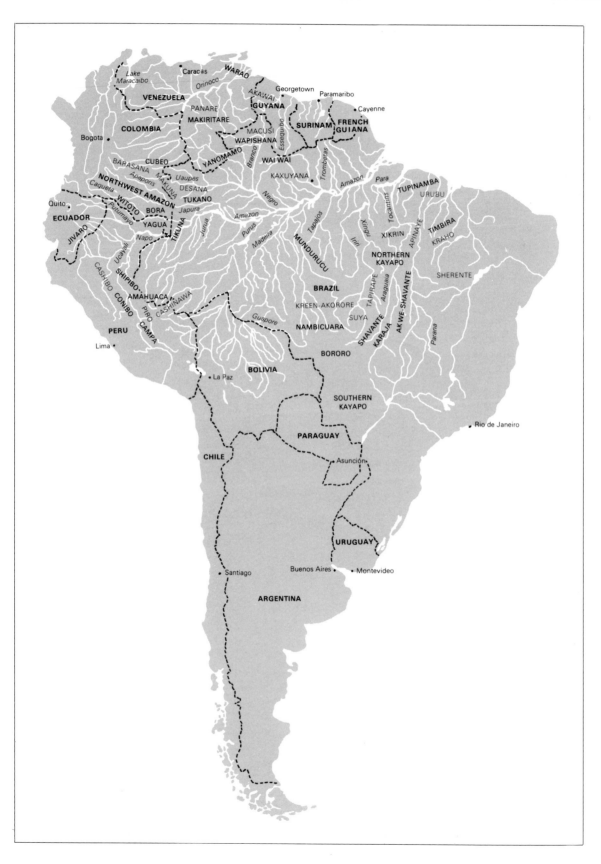

Introduction

Map of South America showing the main rivers of the Amazon and Orinoco drainage systems and the principal groups of tropical forest Indian tribes.

A party of Europeans accompanied by Mojos Indians meeting a party of Carapuna on the Madeira river, Brazil/Bolivia, 1867. The only practical way of travelling for any distance through the dense tropical forest was always along its waterways. The Indian canoe was the ideal craft, being light enough to be carried easily past rapids and waterfalls. Those seen here behind the wooden boat are made from a single sheet of bark.

Much of what is described here is already a matter of history. Ever since the time of first European contact in the early sixteenth century, the Amerindians of the South American tropical forest have suffered many changes and disruptions to their traditional ways of life. The Spanish and Portuguese conquerors seeking 'gold and glory' were responsible for the deaths of many thousands of Indians, not only as the result of battles and massacres but through the diseases which they introduced into the New World against which the native populations had no resistance.

There are no reliable estimates of the size of the population of the Amazon region at the time of the first European arrivals in the area; figures between two and five million have been suggested. There were certainly large numbers of Indians settled along the coast and the main rivers and it was these coastal and riverine dwellers who bore the worst of the early confrontations. Many Indians were forced to flee into the remoter parts of the forest to escape death or slavery.

In succeeding centuries, the activities of missionaries, rubber collectors and other outsiders moving into the forests have continued to force this retreat. Fortunately, the vast size of the Amazonian rain forest has allowed some Indian peoples to survive until the present day living in much the same way as did their ancestors. However, the massive acceleration of

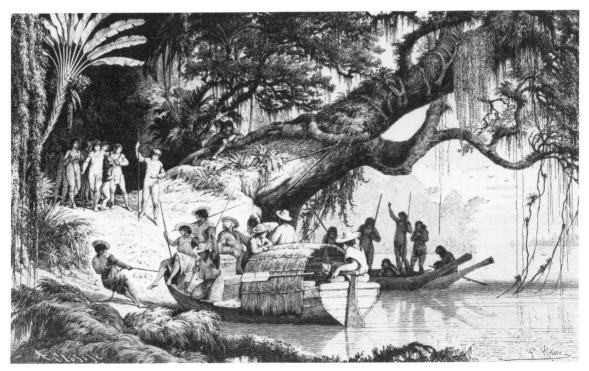

Making rubber on the Madeira river, 1867. The enormous increase in the world's demand for rubber – the 'Rubber Boom' of the late nineteenth and early twentieth centuries – was one of the greatest tragedies for the Indians of the Amazon since the European conquest in the early sixteenth century. In the rush to extract the valuable latex, Indians were not only forced from their land but were also taken into slavery – sometimes a whole tribe at a time.

development projects which have resulted in the clearance of vast tracts of forest in recent years, mean that the remnant tribes are all under threat. Roads, ranches, mining projects push deeper and deeper into the interior and the rapidly expanding non-Indian populations of the countries concerned are asserting an irresistible pressure upon the Indian minorities.

Traditional Indian economies require large land areas for successful survival and the inability of the Indian to defend this need in the modern world results in agonising situations which are difficult to resolve. The Indian reservations in some countries at least buffer changes which seem inevitable, allowing a more gentle process of adaptation. To sustain such projects however requires immense commitment on the part of governments, and it is difficult to be optimistic that this will be maintained in times when other problems seem more pressing.

Currently then, the surviving Indian peoples of the Amazon seem faced with a future little brighter than that of the Indians of North America. Tribes already acculturated live on the margins of developed areas, indistinguishable in terms of their way of life, from the other poor of different origins though often despised by them. Some native peoples drift uneasily between two lifestyles: their own forest-based existence and that offered by mission stations and developing settlements along the growing network of roads. A few, now very few, have managed to withdraw into places so remote that they can continue in their own traditions and beliefs.

The plight of the Indian has been well expressed by Paul Henley, an anthropologist who works in Venezuela: 'Faced with the modern world, many Indians have lost confidence in their own traditions. Once the forest has been chopped down, they have no way of making their own living. Instead many Indians have turned to begging along the new roads, or in

Mojos Indian 'dancing before the altar on a Holy Day', 1867. In many countries of South America today as in the past, the missionaries are the people most concerned with the protection of the interests of the Indian minorities. However the missions themselves have also been an influence for the disruption and destruction of traditional ways of life and the 'spiritual values that give meaning to life in the forest' (S. Hugh-Jones, 1978).

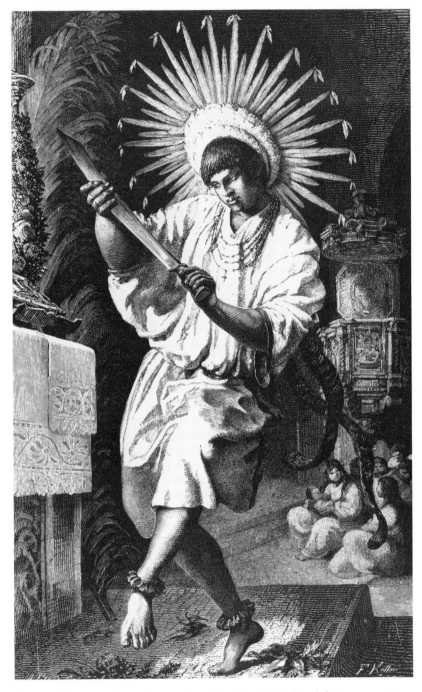

the nearby towns in order to stay alive.' In the light of this, reservations such as the large Xingu Indian Park, set up in Brazil in 1959 by Claudio and Orlando Villas Boas, must be seen as the most acceptable of alternatives for the protection of Indian interests in the welter of modern economic development. It does not inhibit the curiosity and interest in the outside world which many, especially of the younger Indians feel, but allows them to accept or reject what they find there. Sadly, not all the countries concerned offer even this measure of help to the Indian whose wish to preserve his own identity seems destined to be swept totally away in a very short time.

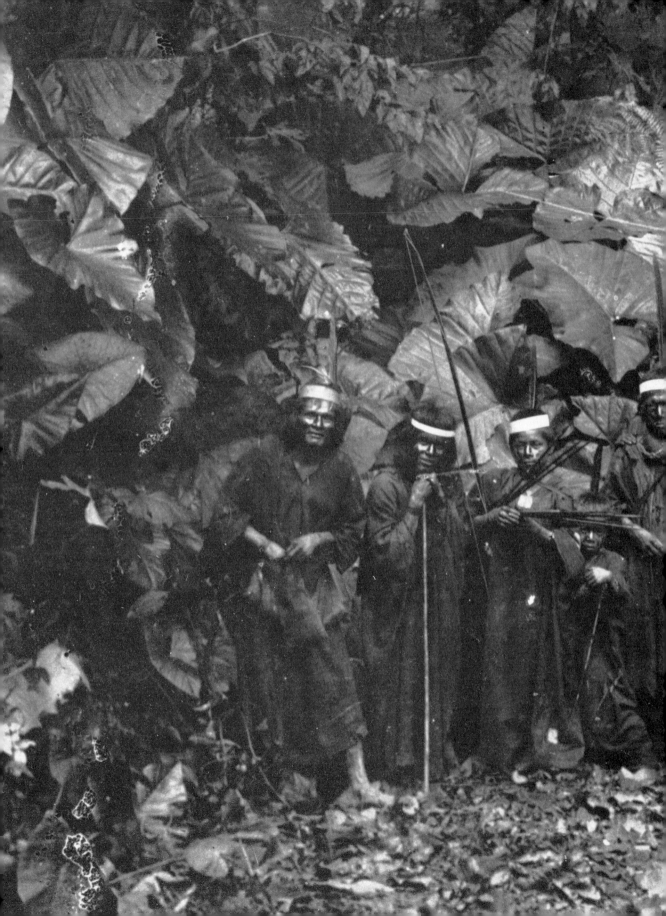

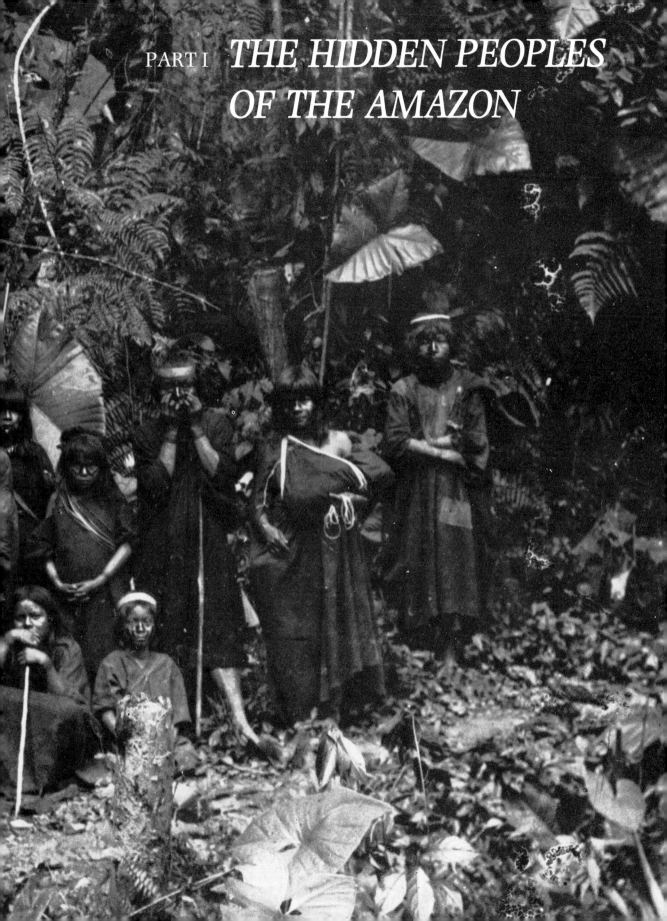

PART I *THE HIDDEN PEOPLES*
OF THE AMAZON

Lowland South America: the Amazon region

The largest river in the world flows through the largest forest. . . .
By little and little I began to comprehend that in a forest which is
practically unlimited – near three millions of square miles clad with
trees and little else but trees – where even the very weeds are mostly
trees . . . a single tree cut down makes no greater a gap, and is no more
missed, than when one pulls up a stalk of groundsel or a poppy in an
English cornfield.

RICHARD SPRUCE, 1849

Richard Spruce, one of the most sympathetic of nineteenth-century botanists to work in the South American tropical forests, could not have foreseen the immense mechanical power that would make it possible in the later twentieth century to sweep away vast tracts of the forest. He well expressed the awe of many early travellers when confronted for the first time by the primeval forest with its 'enormous trees, crowned with magnificent foliage, decked with fantastic parasites, and hung over with lianas, which varied in thickness from slender threads to huge python-like masses . . . now round, now flattened, now knotted, and now twisted with the regularity of a cable. Intermixed with the trees, and often equal to them in altitude, grew noble palms; while other and far lovelier species of the same family, their ringed stems sometimes scarcely exceeding a finger's thickness, but bearing plume-like fronds and pendulous bunches of black or red berries . . . formed, along with shrubs and arbuscles of many types, a bushy undergrowth. . . .'

Portuguese sailing ship of the mid-sixteenth century.

(opposite) A giant forest tree with smaller palms growing up between the buttressed roots. The buttresses are sometimes as much as twelve or fifteen feet high and may help to spread the weight of the tree. Forest soils are often thin and poor; the nutritional needs of the trees are linked with fungi, insects and other plants, often in symbiosis; for these reasons the vast tracts of forest now being felled can never be recreated.

This densely forest-covered land, which spreads over some 2,320,000 square miles of the South American continent is drained by the vast network of waterways which form the Amazon and Orinoco river systems. The Amazon itself is navigable by ocean-going ships for some 2,300 miles of its length and is joined by over a thousand tributaries on its course between the Andes mountains and the Atlantic ocean. It carries one fifth of the world's fresh water which flows from its mouth of the rate of 2,829 million gallons per second (D. Lathrap, 1970), pushing back the salt sea water for miles offshore.

The probable discoverer of the Amazon, a Spanish sea-captain, Vincente Yañez Pinzón, was amazed to find when sailing out of sight of the coast of Brazil in the year 1500 that he had entered what he thought a fresh-water sea which he called *La Mar Dulce*. Today, the Brazilians still call the Amazon *O Rio Mar*, the River Sea. Between the months of November and June the river overflows its banks creating a vast flood plain.

The rivers provide the best routes for the penetration of the forested land since moving on foot is slow, difficult and dangerous. Human settlement of the area has always depended upon efficient water-craft, light enough to be carried over rapids and shallow water. The canoe of the South American Indians was the perfect solution to this problem. Today, light aircraft have made cross-country travel easy although they obviously depend on cleared strips for landing.

The tallest forest trees can be as much as forty metres high and beneath their light-excluding canopy, smaller trees, vines and lianas push upwards. As many as three thousand plant species have been found in one square

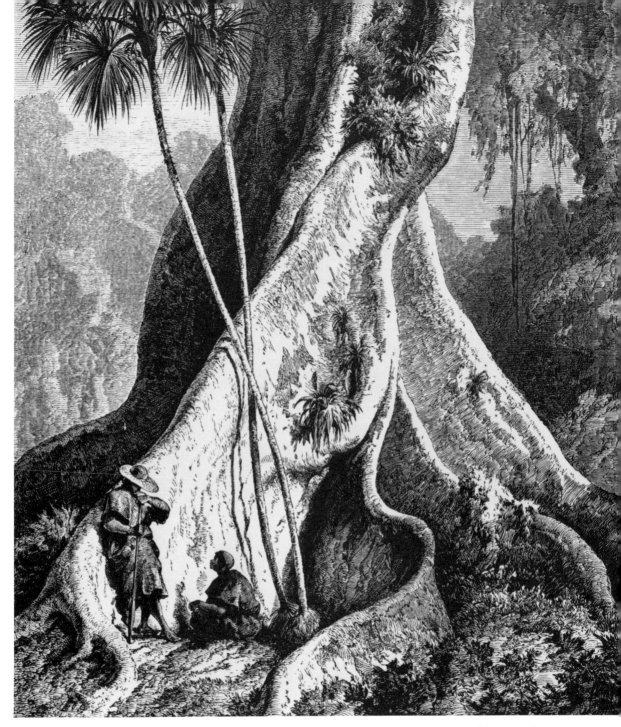

mile of forest – the most varied plant habitat in the world. Dependent upon these plants are birds, animals and insects which exploit every level of the forest cover, eating the buds, leaves and fruits and being eaten in their turn by other species in an intricate and delicately balanced food chain.

The life of all tropical forest Indians is dependent upon an intimate knowledge of the forest and river habitat which gives food, shelter and is the inspiration of their spiritual beliefs. As the source of their existence, its resources have been carefully exploited over thousands of years in non-destructive ways.

The forest peoples

These peoples are very unskilled in arms . . . should Your Highnesses command it, all the inhabitants could be taken away . . . or held as slaves . . . for with fifty men we could overpower them all and make them do whatever we wish.

CHRISTOPHER COLUMBUS' report to the King and Queen of Spain, 12 October, 1492

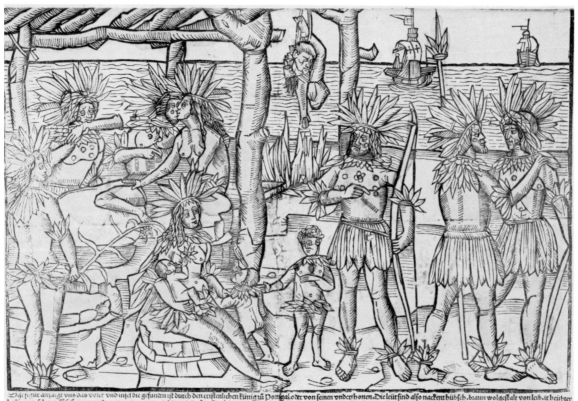

The earliest known woodcut representing Tupinamba Indians of coastal Brazil that seems to incorporate some first-hand observations. *c.*1505. Unlike most Amerindians, the men are shown as bearded. It is also likely that the feather kilts they wear are in fact misinterpreted feather shoulder capes or attempts to interpret a verbal description of men ornamented with feathers. The inscription below is based upon a German translation of a letter of Amerigo Vespucci.

Like all other Amerindian peoples, those who settled the forest lowlands of South America were descended from Asiatic immigrants who crossed into the Americas via the frozen Bering Straits some 30,000 years ago.

The archaeology of the Amazon basin is still in its infancy. The forest vegetation and the climate alike make archaeological work difficult and, moreover, do not favour the preservation of remains. It is however established that people who lived by hunting and gathering moved from North to South America about 15,000 years ago. Certainly by 3000 BC there is good evidence for settlement in parts of the Amazon basin of people living in much the same way as those who were encountered at the time of European contact in the sixteenth century AD.

There is no reliable information concerning the distribution of Amerindian peoples in the tropical forest at the time of the first Spanish and Portuguese explorations. As has been said, the coasts and main rivers along which the first Europeans ventured were fairly heavily settled, the soil being richer here than in the interior of the forest because of the silts deposited by

the flooding rivers. Indian settlement, dependent to a great extent upon the cultivation of root crops, was probably concentrated in these parts.

The early accounts of these peoples describe 'extensive political units, powerful chiefs or kings, priests, temples and idols along the main stream of the Amazon' (Lathrap, 1970), offering a very different picture of Indian culture from that found today. But, even if accepted as an accurate account, these riverine peoples were those 'first destroyed by the combined affects of European diseases, missionization and the slave trade' (ibid).

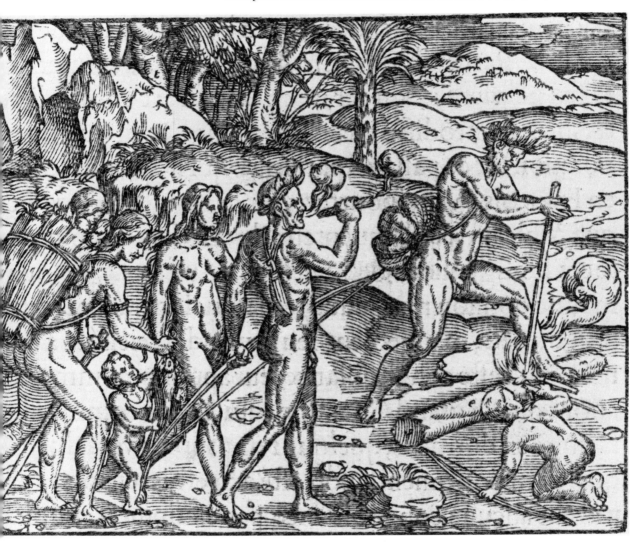

André Thevet published this woodcut of coastal Tupinamba Indians in 1557. Their activities – fire making, cigar smoking and burden carrying – are represented more accurately than is their appearance which is distinctly European. The fire drill is rather large and the carrying straps are not supported on the forehead but otherwise this very early depiction of Brazilian Indians must have been based on first-hand observation.

What has survived, in an area ten times the size of the British Isles, is scattered groups of Indian tribes speaking between them over three hundred languages. Although there are many variations in their culture and way of life, there is nonetheless a broad underlying conformity which makes it possible to speak of a 'tropical forest culture'. Each settlement forms a self-contained unit with little social division or political structure, even chieftains or head-men having limited influence. The shaman, the healer and human intermediary between this world and the spirit world in which Indian peoples believe, is the only person in a village who carries out a specialised activity – all other distinctions are based upon sex and age.

Many attempts have been made to classify the Indian cultures of the tropical forest though no one such system has gained universal acceptance. There is a broad conformity of 'culture area' with 'language group' but in every such division there are many exceptions. There are three main language families – groups of languages which have diverged from a common 'parent' language – Arawak, Tupi-Guarani and Carib. The Arawakan languages have the greatest geographical distribution and predominate in the northwest Amazon and along the eastern foothills of the Andes. Tupi-Guaranian languages are spoken mainly along the Atlantic coast of Brazil and the lower reaches of the Amazon river. Carib languages were once concentrated in the Guiana highlands but were carried westwards in recent times and are spoken in many outlying places as far away as the southern edge of the Amazon basin. There remain many languages, some of them spoken only by a handful of individuals, which do not fit within the classifications and languages from other groups are commonly found within each main language area. Many Indian groups are multi-lingual and, for example in the northwest Amazon, many individuals will speak several languages. For all Indians who have contact with the world outside the forest it is necessary to learn either Spanish or Portuguese.

Linguistic classification assists in determining the origin of particular cultural traits about which there is much debate. Studies of material culture and social organisation help to define those particular adaptations to the tropical forest environment most characteristic of its cultures. Lists of shared cultural elements include the building of pole and thatch houses, agriculture based upon the cultivation of root crops, hunting and fishing practices and the making of basketry and pottery. The technologies associated with these activities are pervasively similar throughout Amazonia as is the kind of social organisation described earlier. The wide distribution of these traits was possible because of the development of the canoe, by means of which 'the canoing tribes were able . . . to diffuse their arts and customs over enormous distances' (R. H. Lowie, 1948).

The rivers

The degree to which the network of huge rivers forming the Amazon system was the major avenue for communication and travel cannot be overemphasized.

DONALD LATHRAP, 1970

River transport
Today the use of the outboard motor is not uncommon among the peoples of the Amazon but for many of them the dugout canoe, handled with great skill and dexterity, remains the chief mode of transport. People have to move through the forest to seek some foodstuffs and materials which have then to be transported to the village. The manufacture of the log canoe is an important male activity requiring considerable expertise at every stage of its manufacture.

Food from the river
Most Amazonian Indians depend to a greater or lesser extent upon the fish

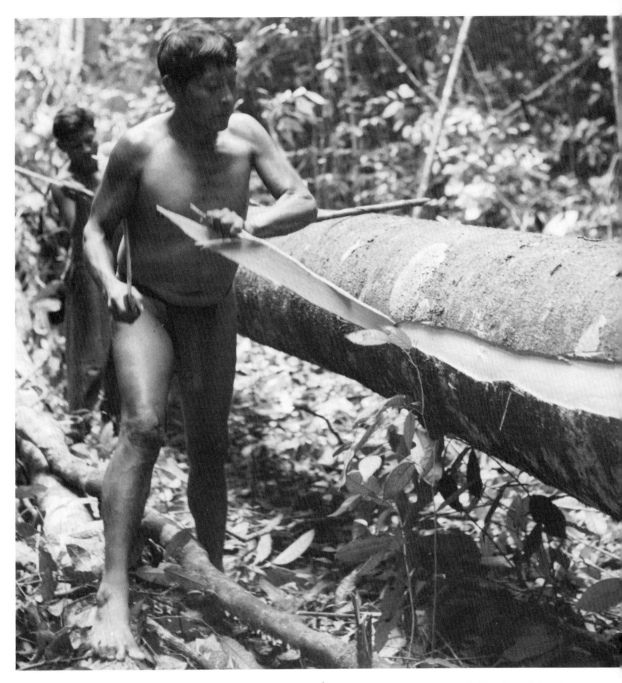

Removing the outer bark from a felled tree for the making of a bark-skin canoe. The bark is peeled back along a slit of the required length. When free from the trunk it is braced by the insertion of wooden cross-members. At each end and on each side, close to the ends of the sheet of bark, four laps or 'tucks' are made which draw the ends up above the water line.

of the rivers as part of their diet. There are many methods of catching them and fishing expeditions are usually a communal activity. The use of poisons is widespread and the plants from which they are derived are both specially cultivated and gathered from the wild. More than one hundred plant species are known to be used in this way and leaves, seeds or roots may all provide the poison with which to paralyse or asphyxiate the fish. The plant material is usually crushed and placed in a basket which is then plunged into the stream to release its poison. The fish can then easily be speared or taken by hand.

Many types of bow and arrow are used for shooting fish; sometimes the

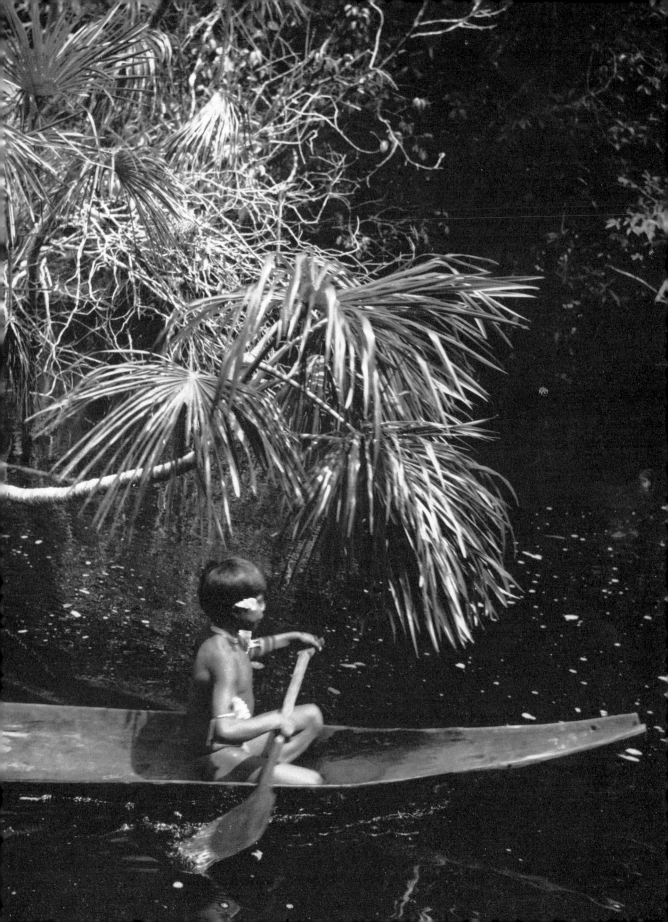

(*opposite*) A Tukano boy paddling a
dug-out log canoe on the Piraparaná
river, Colombia.

same ones used for other hunting but more often of specialised types. Most
fishing arrows are without fletchings since the feathers offer no great
advantage at short range.

The hunter takes up his position above the river on rocks or in a tree at a
place where the fish are already feeding or where he can attract them with a
bait of seeds, berries, ants or spiders thrown upon the water. Fish are also
shot from canoes and harpoon-headed arrows are sometimes used to
capture larger species. Arrows of this type are used for shooting turtles.

When fishing in shallow water where barbed arrows can easily become
entangled in vegetation, simple pointed tips are used. Fish are also speared
in the shallows, sometimes after being entrapped behind a weir of cane or
wooden slats or a carefully constructed stone dam.

Many forms of basketry fish trap were once commonly used, sometimes
also in conjunction with a weir. Fishing with hook and line remains
widespread, the hooks now usually being metal ones obtained by trade but
in former times being fashioned of wood, plant spines or bone.

W.E. Roth records the use of whispering sounds or whistling to attract
fish to the surface where they were either shot with bow and arrow or
caught with hook and line. He also records as a common practice in
Guyana, night fishing by torchlight where fish attracted by the light were
killed with machetes and knives.

At certain seasons of the year, dense
shoals of small fish will migrate along
streams and rivers. At such times,
large numbers can be caught by
simply plunging a conical trap into
the shoal. The fish are scooped out
from the narrower top opening. The
example shown is made from slats of
palm wood lashed together and was
in use on the Mamoré river in 1867.

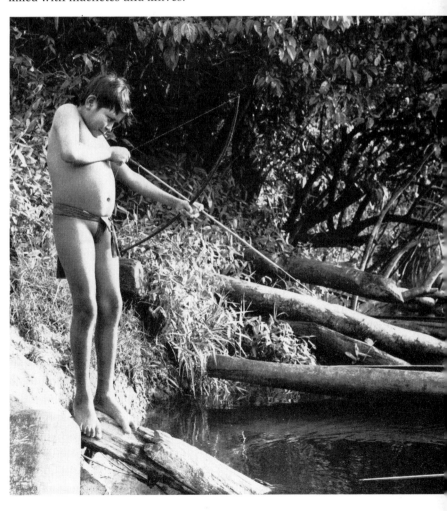

A Guyanese boy shooting fish with
bow and arrow.

The forest: food and raw materials

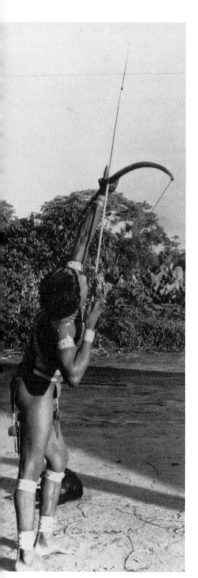

Cashuena man shooting birds with bow and arrow. Cashorro river, Brazil.

Boys learn to hunt from their earliest years, first in play and then by following the men on hunting expeditions. Birds and monkeys of the forest canopy are most easily hunted with the blowgun used by many tribes and still preferred today to the gun in some cases because it is silent and less destructive. The blowgun can be as much as ten feet long. Thin darts of palm wood tipped with poison are inserted, and a puff of breath into the mouthpiece is enough to expel the dart over a considerable distance – as much as 120 feet. The *curare* poison has the effect of relaxing the muscles of the prey which then drops from the tree.

Dr Norman Bisset, an expert in the study of *curare* poisons, has written: 'Called the "flying death" and any number of other fanciful and evocative designations, the arrow and dart poisons of the South American Indians caught the imagination of the early explorers and of scientists and laymen alike. And it is in no small measure due to the study of this group of remarkable poisons that wide fields of botany, chemistry, physiology, and pharmacology have been opened up.' *Curare* is prepared from several plant species, especially those of the genus *Strychnos*, in a complex process often accompanied by ritual.

Bows of wood, some as much as nine feet in length, with strings of twisted bark or plant fibres are used with arrows (again often tipped with poison), for hunting. They are better adapted than the blowgun to the hunting of the game animals of the forest floor such as peccary, tapir, deer and armadillo. Blunt-tipped arrows are however used for shooting birds since they do not damage the plumage.

W.E. Roth (1924) describes various snares and traps used for catching birds and game including spring snares and falltraps. Increasingly, however, the gun is replacing all traditional hunting weapons.

The forest also supplies foodstuffs – fruits, nuts, honey, frogs, ants and grubs. These are sometimes eaten on the spot or are carried home in baskets quickly fashioned from a palm leaf. Wild plants are also gathered for the making of poisons or for use as medicines, or pigments.

All the necessities of life are taken then, from the forest: the logs for house-building, canoe-making and the fashioning of large troughs and mortars; wood for stools, bows and paddles; palm leaves for thatch and house walls; canes for basketry and vines, bark and fibres for cloth, cordage and string. Gums, waxes, resins and oils used, among other things, as adhesives, medicines and cosmetics are also obtained from the plants and animals of the forest.

A knowledge of the properties of plants has been built up by the Indians over thousands of years. Although by no means fully studied, much of this information has already proved of enormous use to the world at large. It would be no less than tragic if it were to be lost forever.

(*opposite*) Two men holding hunting weapons. The Makuna man on the left holds a bundle of long poisoned arrows, their heads protected by a sheath of bamboo and wax. The Yabahana man on the right carries a blowpipe; a quiverful of poisoned darts is suspended round his neck.

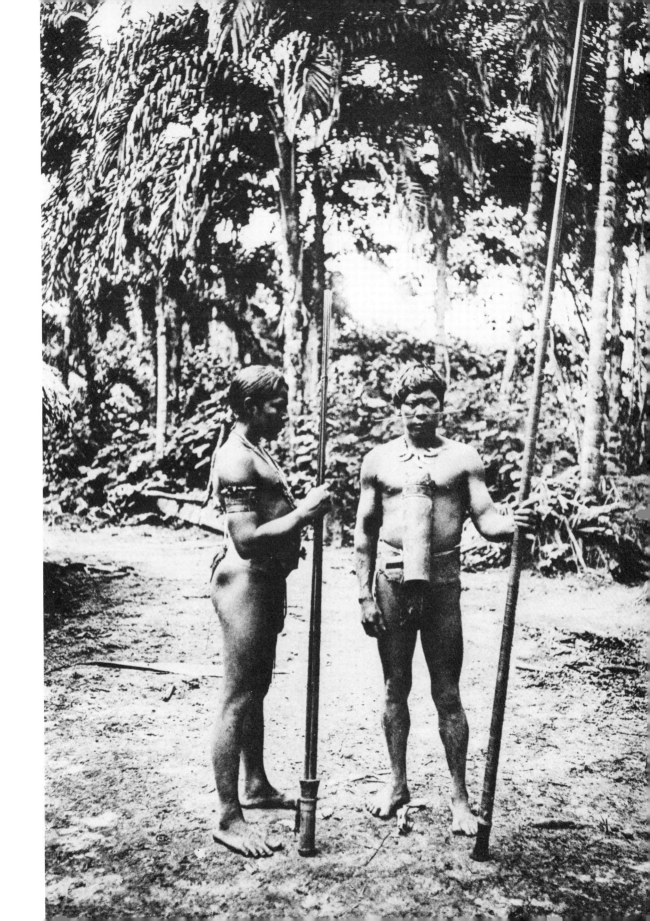

The house and its furnishings

[Indian beds] which they call Hamakes; they are some of them made of cotton wooll, and some of barkes of trees; they use to lye in them hanging.

JOHN WILSON, 1606

A woodcut of 1557 showing a Brazilian hammock. Beneath it a smoking fire keeps the insects at bay.

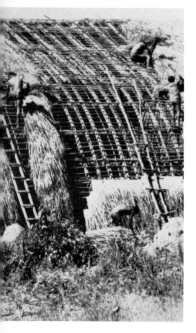

Thatching the roof of a Yawalapiti house, Upper Xingau, Brazil.

There are many forms of pole and thatch house traditional in the Amazon some of which are described by Dr Stephen Hugh-Jones later in this volume. W.E. Roth (1924) also gives extensive descriptions of house-types and building methods for Guyana and neighbouring regions. Of house furnishings the hammock is perhaps the item which seems most to have intrigued early observers. Twenty years after the quotation given above was written, William Davies wrote: 'The manner of their Lodging is this: they have a kind of Net made of the rinde of a tree which they call Haemac, being three fathom in length, and two in breadth, and gathered at both ends. . . . When hee hath desire to sleepe, hee creepes unto it'. This description may well have bemused his seventeenth-century readers but so ideal a portable bed, so well adapted to the conditions of the tropical forest, was widely adopted by many immigrants to the New World. Another kind of bed of which there are early accounts is the *cabane* made from large leaves placed across a lattice of canes and suspended by ropes of plant fibre. In some parts of the Amazon simple sleeping platforms are used or woven grass mats may be placed upon the floor of the house.

Other house furnishings are also described by Dr Hugh-Jones and may be taken as typical for the Amazon region as a whole. However it is worth adding an additional word about pottery vessels. These are widely, though not universally manufactured. That pottery making is a very ancient aspect of tropical forest culture is evident from the potsherds found in archaeological remains, some dating from the late third millennium BC. Even at such early sites the pottery forms seem to indicate the cultivation of manioc: there are fragments of pottery griddles little different from those in use today and the rims of very large, wide-necked vessels of the types which in recent times have been used for making manioc beer. Even earlier dates have been claimed for the use of pottery in Brazil but there still lacks good botanical data which might associate such finds with agricultural practices.

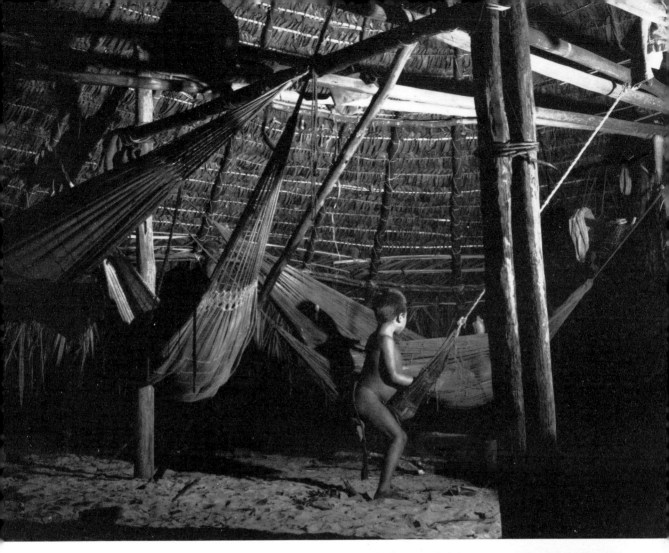

A house interior at Wailamapu
village, Kako river, Guyana, showing
hammocks slung from the cross-
beams. The hammocks are used for
sitting or resting during the day as
well as for sleeping at night.

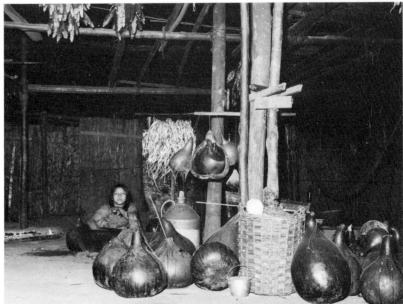

Interior of house at Wailamapu, Kako
river, Guyana, showing the large
gourds used as storage containers.
Bundles of maize are drying in the
rafters.

Gardening and food preparation

For a description of the gardens which are typically found close to houses in clearings made by the slashing and burning off of the forest cover, reference should be made to Dr S. Hugh-Jones' article which follows. By far the most important cultivated crop is manioc, the processing of which he describes and which is the staple food of most Amazonian tribes.

Meat or fish is cooked by boiling in water or manioc juice heavily seasoned with peppers, or smoked on wooden racks (babracots). Small fish, shrimps and crabs are sometimes wrapped in banana leaves and roasted. Fish can also be pounded to a paste with salt for use as a condiment.

Turtles are sometimes cooked (after death) in their shells by being placed in holes in sand over which a fire is built. Turtle eggs and bird eggs are also eaten.

Fire for cooking and lighting was fomerly kindled by means of friction between two pieces of wood, one notched piece being held upon the ground and the other inserted into it at right angles and twisted between the hands until the heat generated would set fire to tinder of dry moss, leaves or cotton.

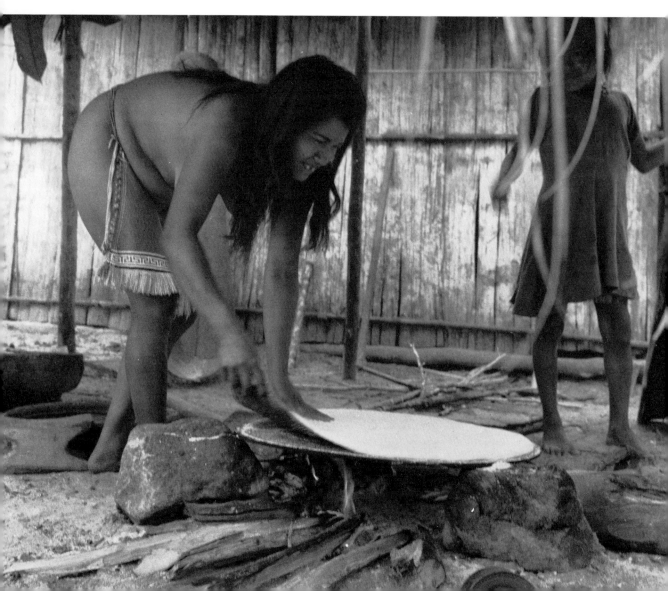

Body decoration and clothing

It would be misleading to lay too much emphasis on the superficial differences between Tchikrin body adornment and our own culture's elaborate array of clothing and hair styles, make-up, and jewelry. Among the Tchikrin, as among ourselves, the decoration of the surface of the body serves as a symbolic link between the 'inner man' and some of his society's most important values.

TERENCE S. TURNER, 1969

At the time of first European contact most observers recorded that the Indians of the tropical forest went naked. Where European dress has not been adopted (see S. Hugh-Jones below) clothing is minimal for all but ceremonial occasions. For women, an apron of beadwork and perhaps leg

(*right*) A Bororo headman, Brazil, 1897–8.

(*above*) An early representation of Tupinamba dancers published by Jean de Léry in 1578. De Léry spent almost a year in Brazil in 1577. The dancer in front wears jingle-rattles made from fruit or nut shells on both legs. The circular back ornament of feathers is characteristic of the Tupinamba of coastal Brazil in the sixteenth century. The dancer behind carries a gourd *maraca* and wears a feather diadem.

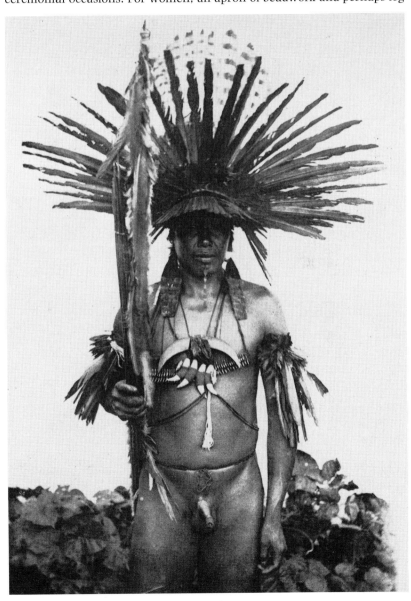

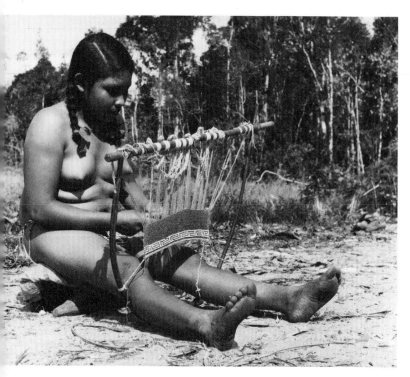

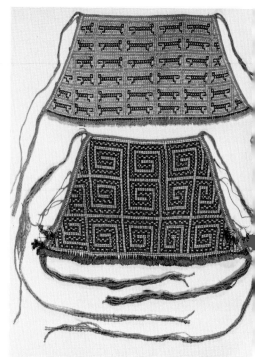

(*above*) A Guyanese girl making a bead apron on a frame made from a bent switch attached to a bar of wood. The vertical warps are of cotton or silk grass. The double-stranded weft of fine cotton is threaded with beads. The loose-ended warps are passed individually between the two strands of weft after every two beads. This results in a close-textured weave which has the same appearance on either side.

(*above right*) Two women's aprons of cotton and bead work from Guyana. The designs are like those used on basketry from the Guianas. The one above has a monkey design and the lower one a stylised snake design.

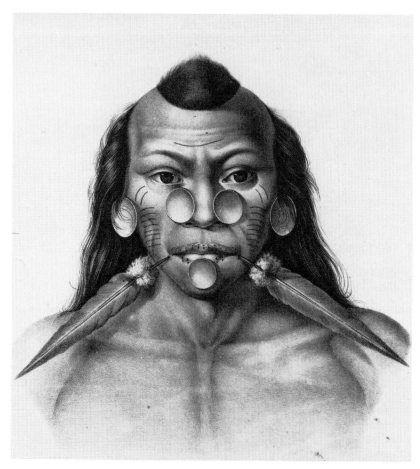

Portrait said to be of a Mayoruna Indian of the Javari river, Brazil/Peru, 1817–20. The lines on the face represent tatooing; the round ear, nose and lip ornaments are of shell. The illustration is perhaps based upon a Mundurucu trophy head in the collection of the Bavarian scientists von Spix and von Martius rather than a field sketch; possibly it is a combination of the two.

A woman of the Ucayali river region of Peru. She holds a baby wearing the device used for changing the shape of the skull. Shortly after birth this frame, with a thickly padded slat of palm wood at the front and a broad band of cloth at the back is placed upon the child's head. Strings or tapes joining the two sections are tied so that a gentle pressure is exerted.

A Yagua man of eastern Peru wearing dress and ornaments of fibre from the *Mauritia flexuosa* palm. Such garments were typical of everyday dress until recent times. Women wore garments of the same fibre and both sexes painted their faces with red and black vegetable pigments.

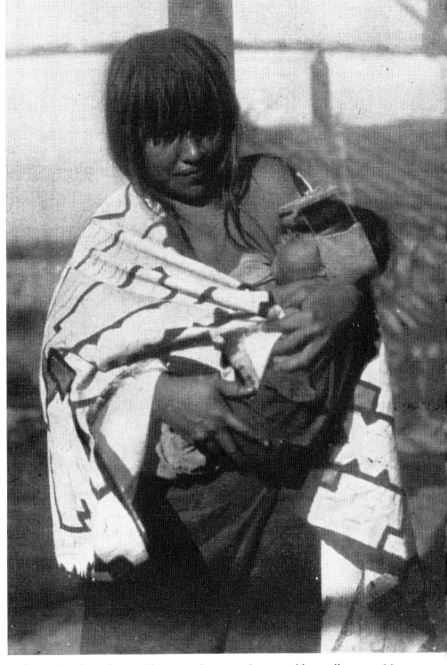

and arm bands and a necklace are the most they would usually wear. Men may wear simple cotton or barkcloth genital coverings attached to a cord or belt about the loins. In contrast to the simplicity of everyday dress, male ceremonial wear is usually very elaborate. Special garments, ornaments and body painting will often mark initiation for both boys and girls.

Permanent deformation of the body such as the flattening of the skull in infancy and tooth filing was probably once much more common than now. Tatooing, however, is still practised by some tribes. The most widespread and elaborate form of body decoration is painting with plant-derived pig-

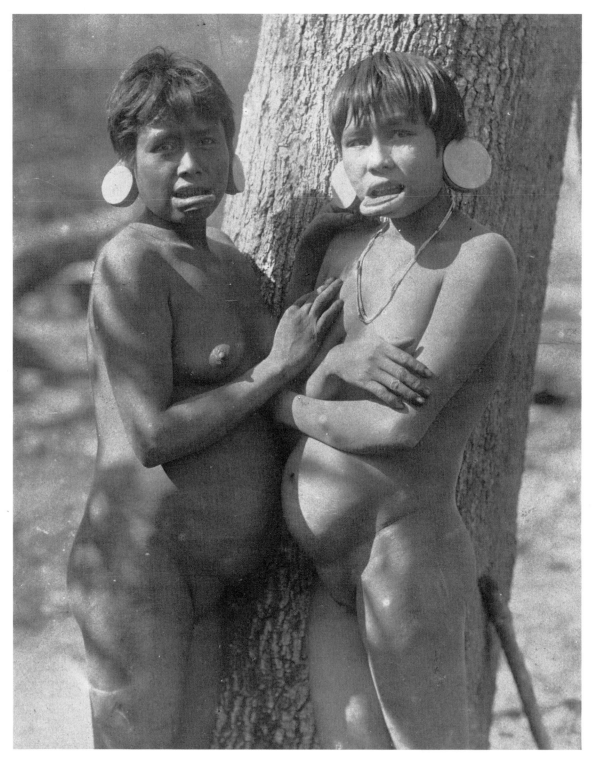

Two Botocudo girls wearing large lip and ear plugs of wood.

ments, the colours being applied by hand or with stamps or rollers. There is also still extensive use of lip, nose and ear ornaments. The large wooden lip and ear plugs of, for example, the Tchikrin and, formerly, the Botocudos are the most extreme examples. Some tribes also retain striking hair styles or hair ornaments worn upon ceremonial occasions.

Rituals and ceremonies

On the one hand, one of the most interesting and significant features of these societies is that, unlike some of the anthropologists who study them, they do not see their kinship, marriage and social organisation in isolation from a wider religious and cosmological order. On the other hand, it appears to be through ritual that the elaborate mythological systems of these people acquire their meaning as an active force and organising principle in daily life.

S. HUGH-JONES, 1979

A procession of masked dancers, Solimões river, Brazil, 1817–20. These masks of the Tikuna and Jurí-Taboca were made of painted barkcloth and were worn, according to the Bavarians von Spix and von Martius, at ceremonies associated with the birth of a child. They represent the Yurupary and stormwind spirits and the bird and animal spirits of the forest.

The important events of the life-cycle are accompanied by the observance of rituals. Christine Hugh-Jones, writing of the Barasana of the northwest Amazon, records that after the birth of a child which takes place in the manioc garden near the *maloca* the 'mother and child return to the house, entering through a side door. Prior to entry, beeswax is burned and all household goods – ritual items, pots, coca-equipment and so on – are moved onto the plaza to prevent contact with the blood of birth which would injure those who use them later.' For several days the child and parents are confined to their family compartment within the *maloca* and

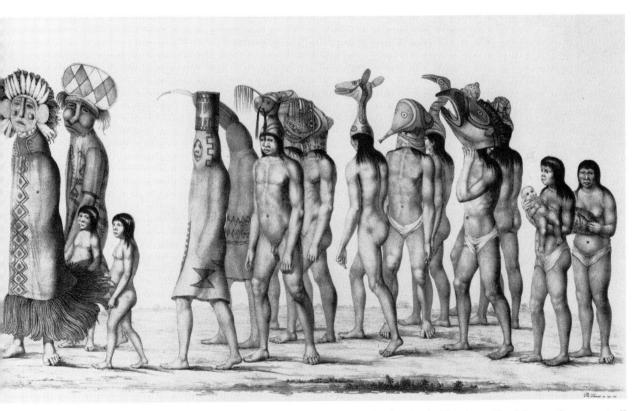

allowed to eat only certain foods which, like the milk of the mother, must all be 'shamanised' (the shaman 'blows' spells upon them to make them safe). After this their bodies are smeared with red paint and they go down to the river to bathe and finally return to the house, which has been prepared as before, to eat a special meal of small fish and peppers.

A line of Karapana (Tukano) dancers from Colombia. They wear full ceremonial regalia and carry gourd *maracas* with incised geometric designs.

At the time of their initiation into the adult world both boys and girls will usually have to go through a ritual which again may involve periods of seclusion, the eating of only certain foodstuffs and, perhaps, an ordeal of some kind such as whipping, tatooing or being subjected to ant bites. Special articles of clothing and ornaments are put on, the hair may be cut and the body painted with colours and designs which announce the individual's new status. These rituals of initiation mark the beginnings of maturity, the weakening of the tie with the nuclear family and readiness to participate in the life of the wider community.

These important events and the other ceremonies which may be held throughout the year, in association for example with the harvesting of certain crops, are all marked by communal festivities. The finishing of a new house, the clearing of a new garden will be marked by a gathering of several communities for feasting, drinking, dancing and singing. Such occasions are important in cementing good relations between villages and allow opportunities for courtship and the exchange of goods and news.

Musical instruments play an important part in ceremonies and festivals and some are themselves sacred objects like the Yurupary trumpets of the Tukano. Huge wooden slit-gongs were used in the past for signalling and summoning people to festivals. These are now very rare though the drums, flutes, rattles and stamping tubes are all still in use.

Shamanism and the use of tobacco, snuff and hallucinogenic drugs

Shamans are thus ranked according to their knowledge and abilities. Their powers are founded upon their knowledge of myths. Most adult men know a considerable number of myths but shamans differ from the rest in two respects: first, they know more myths, and secondly, they know and understand the esoteric meaning behind them. In the hands of the shamans, myths are not merely sacred tales or stories, but things with inherent power. . . .

S. HUGH-JONES, 1979

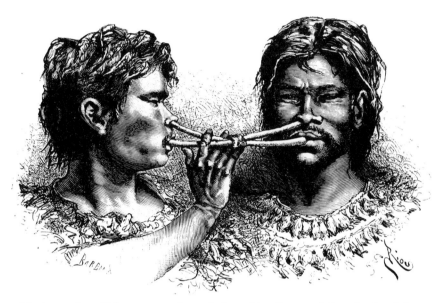

Two Witoto men taking snuff. The tubes for inhaling snuff are of many forms. This example is made of bird bones joined together with wax. Each man can puff the powder into his partner's nostrils. The taking of hallucinogenic snuffs is an important part of ritual for most Indian tribes of the Amazon. Tobacco, coca, *yopo* (*Anadanthera* sp.), *Virola* sp. and other plant snuffs all induce the visions which put men in touch with the spirit world.

Most people will have some knowledge of healing and the plants of the forest that can be used as medicines. The shaman however, in this as in his knowledge of the myths, is pre-eminent. By putting himself in contact with the spirit world, he can locate and remove the source of the illness which is often thought to be some substance or object projected there by some other evil shaman or spirit.

The belief in a spirit world which exists as the counterpart to the real world is universal in the Amazon. The variety of such beliefs and the myths through which they are expressed is great and too complex to be discussed here. All men can enter into contact with the spirit world by wearing ceremonial regalia and using hallucinogenic drugs, but the shaman is 'able to perceive this other-world aspect of existence at all times' (S. Hugh-Jones, 1979). In the northwest Amazon and other parts of the tropical forest, shamanism is much associated with jaguars and jaguar-spirits and the shaman is believed to be able to transform himself into a supernatural jaguar. There is a considerable literature on this topic, for example Professor Gerardo Reichel-Dolmatoff's *The Shaman and the jaguar* (1975).

Smoking can be a purely social activity but is more important as a ceremonial practice. Early depictions show shaman shaking rattles and puffing smoke from large cigars. Both are still aspects of shamanistic ceremonial. Smoking is one of the means the shaman uses to induce the

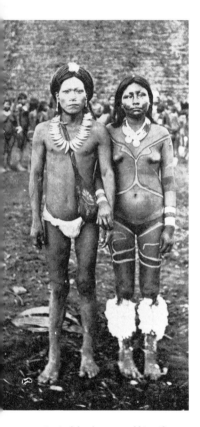

A Cashuena man taking snuff through a tube, Cashorro river, Brazil. The snuff is offered by the shaman; he holds it in a tray decorated with carvings of jaguars. Both men wear full ceremonial regalia which in the case of the shaman includes decorative tufts of down glued to the body.

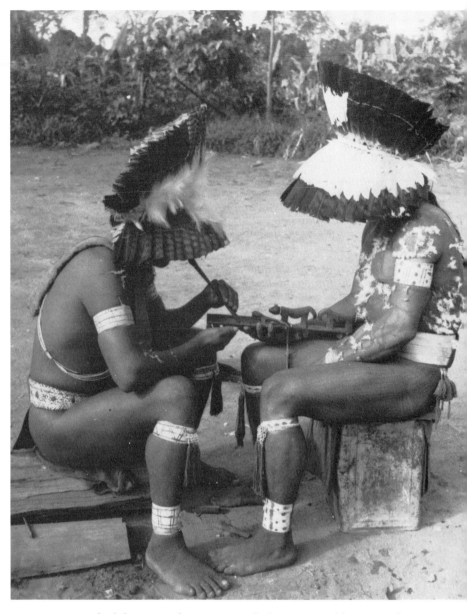

An Andoke shaman and his wife photographed by Thomas Whiffen in 1908. The shaman is the only member of an Indian community who has a specialised role. By virtue of his contact with the spirit world he is both a healer and a guide through all the important rituals and events of an individual's and a community's life.

trance state in which he can make contact with the spirit world. Among the tribes of the Upper Xingu this state is called 'seeing-smoking'. The shaman will also blow smoke over the food and drink to be taken at feasts and similarly prepare the objects to be used in ceremonials.

The preparation and use of coca and the other important hallucinogen, *yagé* (*Baniopteris caapi*), are described later in this volume by Dr Stephen Hugh-Jones. It is worth mentioning here two other hallucinogenic drugs much used in tropical South America: *yopo* (*Anadenanthera peregrina*) and *epená* (*Virola theiodora*). Both are taken as snuff using special tubes, usually made of hollow bones or plant stems. As with coca, *yopo* can be taken as a daily stimulant but is used by shaman to induce trances in which they see visions and 'travel' in the spirit world. *Epená* is taken and used similarly. The history and use of hallucinogenic plants is well described in Richard Evans Schultes' and Albert Hofmann's *Plants of the Gods* (1980).

Warfare and trophy taking

They spy out the enemy's huts at night and attack at dawn. . . . They attack with loud yells, stamping on the ground and blowing blasts on gourd trumpets. They all carry cords bound about their bodies to tie up their prisoners, and adorn themselves with red feathers to distinguish their friends from their foes. They shoot very rapidly and send fire arrows into the enemy's huts to set them alight. And if they are wounded they have special herbs with them to heal their wounds.

HANS STADEN, 1557

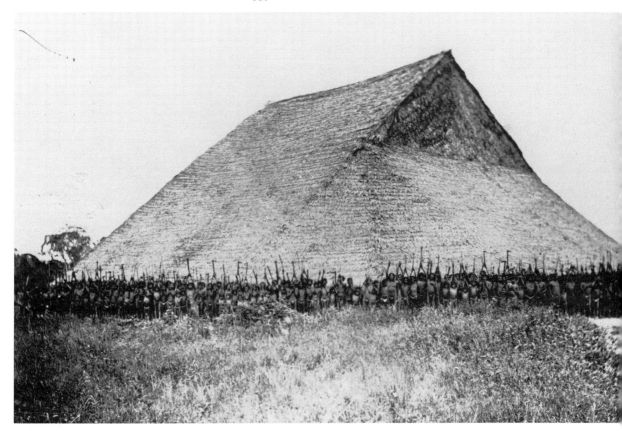

A Witoto communal house of the northwest Amazon with a war party assembled before it; photographed by Thomas Whiffen, the explorer, in 1908. This photograph is remarkable for showing both the size of the house and the size of the war party which, Whiffen notes, carries 'some Brummagen goods' among their weaponry. Despite its size the house would only be used for a few years before the inhabitants moved on to make a new garden elsewhere in the forest.

Warfare is now very rare. Where fighting still goes on it is usually a matter of one village making a raid upon another of the same tribe rather than the full-scale inter-tribal warfare described by early observers. Even in the past, warfare was not usually carried out to make territorial gains, but was rather undertaken to revenge real or supposed wrongs. With some tribes it was practised as a sport, or to prove the prestige of warriors. War could also be waged to take prisoners – as slaves or for cannibalistic rites.

The weapons of war were the bow and arrow, the club and the spear. Poisons distinct from those used in hunting were sometimes employed to tip arrows and lances. Poisons used in warfare were prepared from the fruit and latex of certain Euphorbiaceae, and caused death in agony, unlike the *curares* (Norman G. Bisset).

Skulls, scalps, hair and teeth were all taken as trophies but the most

35

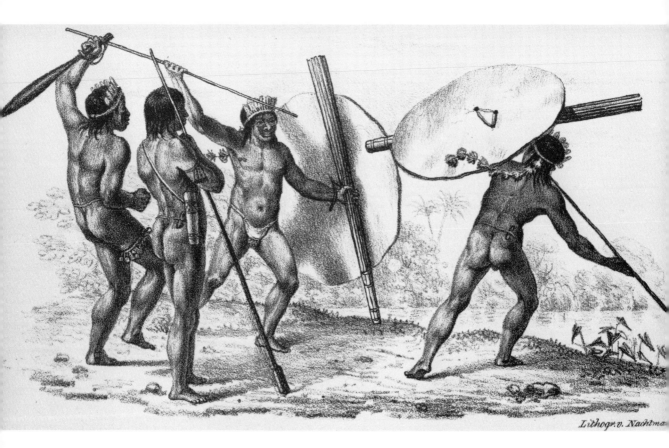

Lithogr. v. Nachtma

A Jurí war dance, Japura river, 1817–20. All the weapons of warfare are carried in this dance. The wooden club, the long darts (possibly tipped with poison) and the protective (tapir?) hide shields. Shields were sometimes made of wood and seem to have become obsolete in most places long ago.

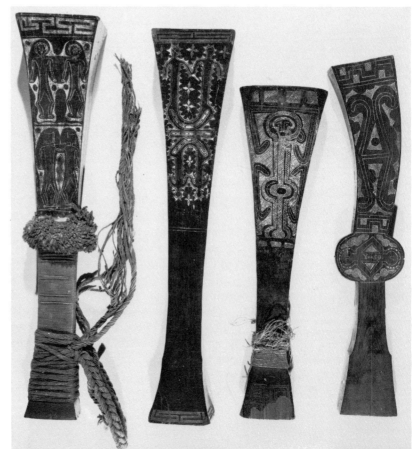

Wooden war-clubs from Guyana. The clubs are decorated with anthropomorphic and geometric incised designs.

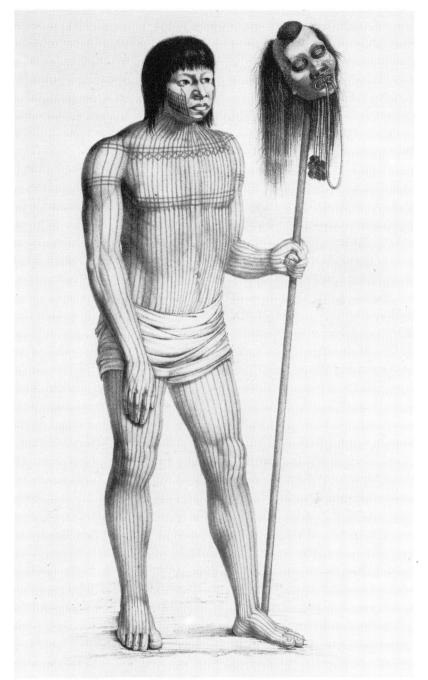

A Mundurucu man of Brazil holding a trophy head on a pole. The Mundurucu did not shrink the heads taken in battle, but they were dried and stuffed and the eyes were sealed with wax and rodent teeth or shell.

Shrunken trophy head (*tsantsa*) made by the Jivaro (Shuar) of Ecuador.

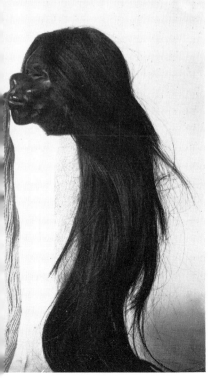

famous example of this practice is the shrunken heads of the Jivaro (Shuar) of Ecuador. After removing the skin from the skull and preparing it in boiling water, the Jivaro shrink the skin using hot stones and sand. It is then moulded so that the features are retained, the lips being pinned together with slivers of wood, bound with cotton string. This head, or *tsantsa*, 'is an object charged with supernatural power' (R. Karsten, 1935). Its preparation is accompanied by elaborate ritual culminating in ceremonial feasting, the object of which is the protection of the warrior from the spirit of the dead person.

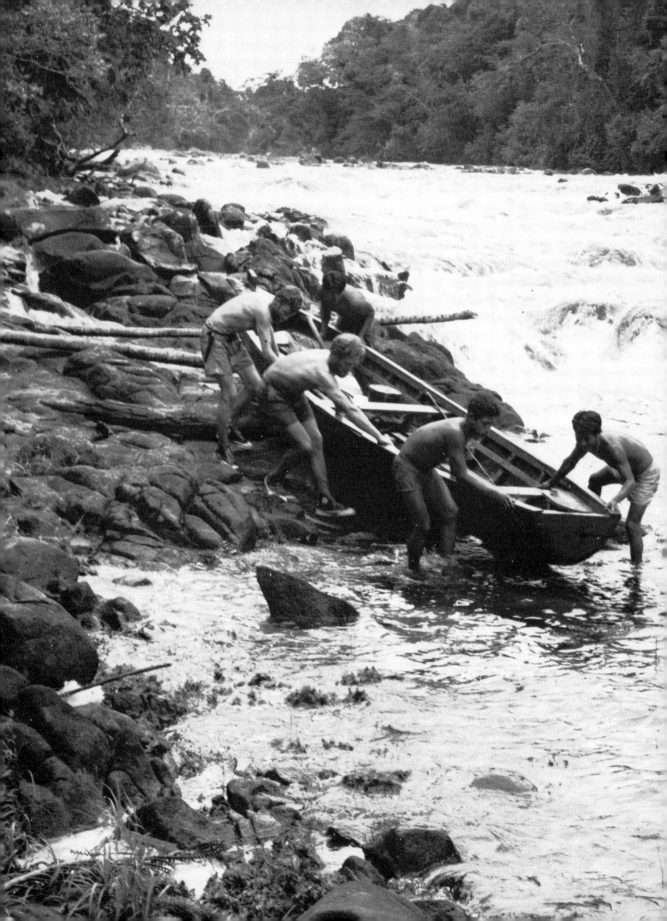

PART II *THE COCAINE EATERS*

Introduction

(*previous page*) Brian Moser and Donald Tayler negotiating rapids on the Piraparaná with the help of Tukano Indians.

The journey to the North West Amazon was, I suppose, the most difficult of a number of journeys which Brian Moser and I undertook in Colombia during our fifteen months of travelling in 1960 and 1961. We had been advised that the river Piraparaná was known to be dangerous to navigate on account of its many turbulent rapids and falls. We had also been led to believe that the reception we might receive from the Tukano Indians living there might not be overly cordial. No one, as far as we were aware, had attempted to follow the river throughout its entire course although the German ethnologist Theodor Koch-Grünberg, and Richard Schultes, the Harvard botanist, and a few rubber collectors, and a missionary had visited or travelled over sections of the river.

Although the thought of adventure in relatively unknown regions may have had its fascination, our intentions were primarily to record the music of the Indian people living along the river, and to make collections of those cultural materials which they were willing to exchange for cloth and beads and other items which we had brought with us; items which were rarities in these remote areas. A secondary objective was to carry out a geological reconnaissance and to make an aneroid and compass traverse to map the course of the river. Subsequently, on a second journey to the lower Piraparaná, we made an ethnographic documentary film depicting some days in the life of one group of Tukano Indians: the Makuna of the Komeyaka.

On our first expedition we had to witness the loss of a part of our hard won collection as the canoe within which it was being transported capsized in rapids. On our second journey worse was to come, for it was we ourselves who were accidently swept over some falls with all our equipment. We were lucky to survive without injury and miraculously without loss or even serious damage to our recording and film equipment, although diaries, cameras and some personal possessions were lost. Perhaps it was our bare-foot and rather forlorn appearance, resulting from our mishap, which appealed to Makuna sensibilities and humour and which enabled us to film and record in more relaxed circumstances than we might have otherwise expected.

Our report of the survey work on the Piraparaná has been published elsewhere, as has our account of the music, and the story of our journey. One aspect, however, that has not been sufficiently recorded until the present has been a description of the very items which we went primarily to the Piraparaná to collect. The information we now have available on these various cultural materials and of their social context is wonderfully detailed and far more precise than anything we could have undertaken in the early sixties, as we were relative amateurs in our fields of interest and particularly in that of anthropology. It would be true to say that the Piraparaná and its surrounding area of Tukano speaking peoples has, since that time, become one of the most intensively studied areas of indigenous life on the south American continent. Therefore it is as a collection of greater intrinsic interest now than it would have been when our collections were originally given to the British Museum.

Unlike Brian, I have never returned to the Piraparaná. He however has on several occasions, and he has witnessed some of the changes that have taken place in this once isolated and remote community of tropical forest manioc cultivators. Now there are mission stations along the course of the

river, and airstrips, while the Tukano themselves have changed, at least outwardly, for the most part adopting European clothing and other utilities from the west. Whether they have changed all that much inwardly, in their attitudes and beliefs, is another matter. From the accounts which have been written about these people over the past two decades, it would seem that much of their old ways and traditions still continue, in spite of their outward trappings.

Of our companions on that first journey, our two Indian guides are still alive and well. Without them and others we could never have made the journey, and there were times when, perhaps sorely tried by our apparent restless urgency, so alien to a people like this, that they could have understandably left us, but they didn't and we are grateful for that. Our other companion, and a splendid one, was Horacio Lopez Uribe. Shortly after we returned to England, he went back to travel again in his beloved llanos of the upper Orinocco, and was never seen or heard of again and has sadly been presumed dead for many years now. On our second journey we had

'The Tukano would never accept cloth, fish-hooks or beads from us without a thorough previous inspection. The colour of the cloth is of prime importance, its strength would be tested, as would that of the fish-hooks and nylon line, and the test for a good bead was to place it between the teeth – to see if it cracked.' (B. Moser and D. Tayler 1965).

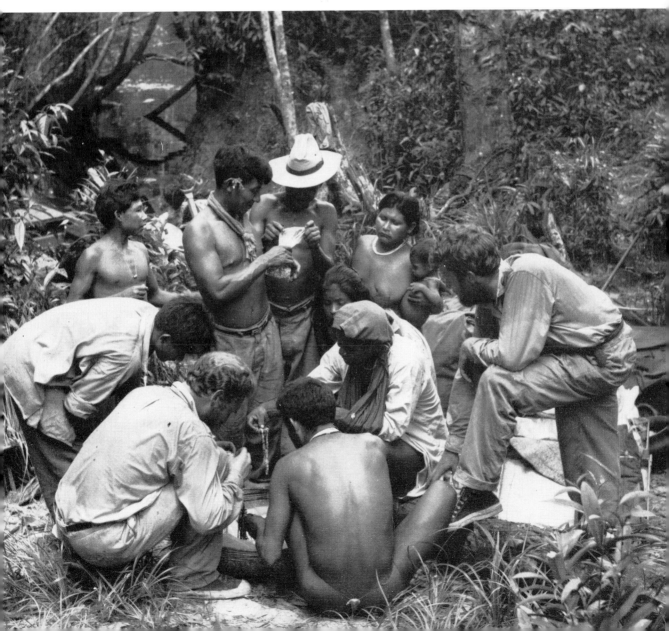

Negotiating a shallow root and liana-choked channel. Colombia.

the good fortune to have with us a gifted Dutch cine cameraman Niels Halberstma and his wife Hannah, and also the assistance of Carlos Balcazar, a rubber collector from the Miritiparana, who had married into a Tukano family.

As for our venture, the recordings, photographs and collections apart, the memories remain. There were the endless days on that first journey of cutting our way through dried up river beds, hauling our wooden boat and backpacking supplies at the end of the dry season, and voracious ants invading our camp sites. There was the strangely primeval struggle between a huge water snake writhing momentarily over the rain-spattered water, in the grip of some unseen assailant, as we sat shivering in our rocking boat, caught unexpectedly in one of those fierce and cold southerly windstorms to which the Amazon is prone, and the time when pushing the boat in shallow water we all simultaneously lept into it for refuge as a huge anaconda slowly and gracefully glided beneath us. Then there were the magnificent *malocas* or communial houses with their cathedral-like interiors, like oases in the endless forest, and the gentle manners and hospitality of their inhabitants – and the rare occasions when that hospitality was not forthcoming, when there was an air of nervous tension. Then there were the sounds of the forest at night, and of the *molocas*; the incessant beat of the coca being pounded in huge cylinders; the rhythmic cadence of rubbed tortoiseshells, the sounds of pan-pipes and the massed cacophany of a Tukano festival.

I like to think, if we did very little else, that we may have influenced others, better qualified than ourselves, to go to this still marvellously untouched area of the Amazon, to give us through their own experience and writings, a greater understanding of the lives of these fine people. One's only sadness, even remorse, in all this was that perhaps we hastened those very changes which we now decry and which have taken place, perhaps for the better, or perhaps for the worse. That will have to be a question which the Tukano themselves will now have to resolve, providing they are given a chance to make their own choice.

DONALD TAYLER

The Tukano

Travel in Amazonia is almost entirely by water; on the smaller rivers by dug-out canoe, on the larger ones by launch or even steamer. In headwater areas it is frequently necessary to cross from one river system to another, and to do this the Indians and *caucheros* make portages or paths, along which they can carry their canoes. Portages are also used to skirt long sections of rapids where it is too dangerous to take canoes through the river. With five of us, three pulling a rope attached to *El Diablo*'s bows and two pushing from behind, it took only four hours to cover the mile over the watershed. On the flat pathway with the boat's hull sliding smoothly over rollers cut by the Indians, there was little difficulty. But when we had to heave the canoe out of the gullies it took us all the effort we could muster to bring the heavy water-logged craft – which weighed eight hundred pounds – out of the root-strewn quagmire on to the sandy track.

One day canoes appeared gliding towards us, both loaded down with large wicker baskets of *farinha* and paddled by two men in loincloths. Strings of minute white beads were around their necks and black berry bracelets around each arm. An old man, his wizened face eyeing us suspiciously, was sitting in the bows of the first canoe.

This was our first real contact with the Indians of the Piraparaná. Their immediate reaction was not one of fear, but rather, like our own, of enquiry and interest. They said nothing until José hailed them in their own dialect. There ensued a long, almost formal exchange of greetings which we were to hear many times when travelling through their territory. Before they left we asked them to carry a message for Nestor – in case they should meet him, for they were travelling to the Río Ti.

The last days before reaching the first Tukano house on the Piraparaná were not easy ones. At one point we had to cross two formidable waterfalls where all the equipment and fuel was carried overland, while we dragged the boat over the riverside rocks to avoid the midstream torrent. *El Diablo* began to show severe signs of weakness. The ribbing above the hollowed log hull began to give and the planking above it worked loose at the joints. Large lumps of pitch came astray and we found ourselves caulking her sides with strips torn from our trousers. On many occasions we hit submerged rocks and logs, and the further we went the more we had to bale. Once a jagged rock edge pierced a large hole in the bows and water came gushing in. One thing was certain: an aluminium boat would by this time have been ripped to pieces.

We made camp one night on the driest land available, near a junction with another tributary. It was an unhealthy spot with bats swooping low beneath the trees. Later one of our guides had his toe incised by a vampire bat and woke in the morning to find his hammock soaked in blood; these bats often carried rabies. While Horacio was making breakfast, a scorpion ran up his arm. When he yelled, José, who was standing close by, flicked it dexterously into the hot ashes of the fire.

Some days later, after an unusually long stretch of paddling, we jumped into the water to pull *El Diablo* over a fallen tree. A large boa constrictor unfurled itself from beneath the boat, shot between our legs and zigzagged swiftly through the water in front, its dark green body coiling and recoiling as it vanished down the river.

It is a mistake to think that the forest is alive with poisonous reptiles and

fierce animals. The discomforts stem from ants, insects and many varieties of stinging flies. We rarely saw wild animals although birds were quite plentiful. In this higher part of the river, a particular small bird would always warn all other creatures of our approach with a piercing three-note whistle. Calling louder and louder it was answered by others in the vicinity. The noise was rending and the more we talked, the more it sang. The Indians called it the *Wa-pey-yer*, and we later heard this bird had driven some explorers mad.

For the first time in a week the sun pierced the thick canopy of leaves, catching the shining emerald, blue and yellow wings of giant butterflies. As the day wore on and the river widened, trees and creepers came right down to the water's edge, their leaves reflected peacefully by the calm surface. Sometimes the thick green foliage was covered in pale purple flowers, rather like lilac, whose sweet smell floated across the water as the boat moved through the beams of sunlight. It was warm and the scene had changed. We were no longer enclosed and we only once had to jump into the water to guide the loaded boat through a rapid.

The trees' shadows were lengthening across the river and three white egrets glided ahead of us. José's voice broke the silence: 'Only one more turn and we reach Kuarumey's *maloca*. His father was a famous chief who refused to allow any white man to enter the river – now he is dead.'

There in front of us rising from the water's edge was a clearing of green manioc with an expanse of sky behind. We paddled the boat alongside the wooden canoes moored to the bank, while in the dusk we could barely distinguish the features of the Indians as they came down the path towards us. They carried no arms and seemed to be friendly. We found ourselves stumbling up the path in the darkness, following our laden hosts, very glad to feel the good dry earth beneath our bare feet and the warmth of the fires inside the great *maloca*.

Now was the time to collect our thoughts, to reorganise the equipment and to decide how we were going to carry out our work. The surroundings, the atmosphere, the Indians, everything was new. Each day, when evening arrived and we had eaten, we would sit across our hammocks and read by the light of a candle, or write up the day's events in our diaries. On Friday 6 January Brian wrote:

'Did not sleep very well last night, probably because I had taken a large mouthful of coca just before getting into my hammock. Nearly choked, the fine green powder making it virtually impossible to breathe; so had to run down to the river and wash my mouth free. The Tukano must have a special method for swallowing it.

The women got up very early, long before dawn, but I couldn't tell the time because my watch was lost on the way over the portage – too bad. They rubbed down manioc and the continuous noise made all further sleep impossible. Horacio left for the river before first light to develop a film he had taken with his old Rollei, also one of mine to see whether I'm giving the correct exposure in these dark conditions. He prepared the hypo last night and has to develop before the water temperature rises.

At dawn Kuarumey opened the door and the cold air rushed into the *maloca*. I went out to the jungle to relieve myself, armed as usual with a bottle to collect a humus sample. We do this nearly every morning – all these tiny bottles. I wonder whether the American drug company will ever

The dug-out log canoe is thinned and toughened by slow charring over a fire to make it lighter and stronger. It should not actually burn but if it catches light the flames are quickly extinguished with mud and leaves. Water would cause cracking. Taiwano (Tukano), Colombia.

discover a new Amazonian anti-biotic? Lovely pale pinks and delicate blues, the mist rising in great banks off the forest, and dew dripping from the trees. It was so peaceful and cool. . . . It's now late, a woman is still rubbing manioc somewhere in the darkness: they always seem so willing to help us, but Kuarumey, no . . . he's sitting beneath the *bréo* flame taking coca with two other men. He is silent and has offered little real assistance; I wonder whether he resents our presence here.'

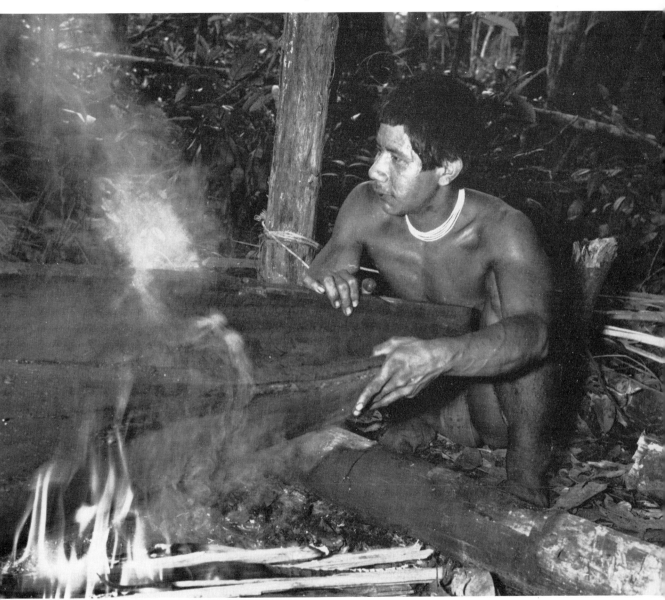

He was a striking man, tall and rather gaunt, with a proud almost arrogant manner. There was no doubt as to who was the head of the *maloca*, nor that we were visitors, fortunate to have his hospitality. We saw little of him during the daytime and it was some time before we learnt he was making a canoe some distance away in the forest.

Though the Tukano travel through the forest on hunting expeditions, canoes are used to go further afield, to fish or to trade with other groups.

45

They are a river people as much as a forest people, and like many Amazonian tribes they have evolved their own methods of making canoes.

A tree – a hard type of cedar – had first been felled, then a twenty-foot section was cut and barked, and allowed to lie for several weeks, before Kuarumey started to cut the wood. Each day he went to the clearing, setting up a palm frond to shade himself when the midday sun broke into the clearing, through the gap in the trees overhead.

Using his *azador*, a curved hoe-like blade, and a long stick with a sharp metal end, he first shaped the outside of the log, scraping off the bark. Then he made holes along its length and began to cut out the centre. It was hard

Forcing in wooden wedges to brace the sides of a dug-out log canoe during the burning process. Taiwano, Colombia.

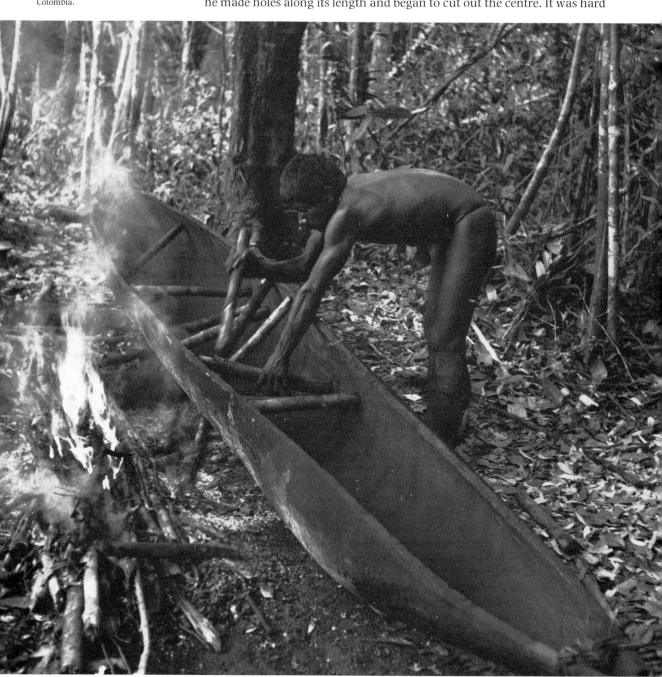

work and he would often break off to make himself a cheroot, using the rolled leaf of a palm, while his eldest son continued the work. Once he disappeared in the jungle to set a monkey trap, a ring-snare high in a tree with fruit as the bait.

He worked carefully, feeling the sides of the canoe so as not to make the shell too thin. After several days it was ready, braced with two small stumps to prevent the sides from closing. Then Kuarumey and several Indians from the *maloca* dragged the hull along the forest paths to the river bank nearly a mile away.

Now the canoe was ready to be warped by burning. This could be undertaken only at certain times of the year when there was no risk of rain, for water on the hot wood might split it. Before they obtained iron and steel the Indians used to cut the trees with their stone axes. They would only partly shape the hull and burn out the centre with fire. Now, with the canoe already shaped, the burning was quicker and it would be completed within a day.

The tinder-dry wood heaped underneath was soon alight and Kuarumey, helped again by his son, began to turn the hull, holding the canoe on rollers, first the right way up, then upside down and lastly on its side. Every so often Kuarumey reached for his coca bag and shook some of the powder into his mouth. Gradually the sides of the trunk were forced open and wedges were placed along its length.

All day long they worked on the smouldering canoe. About midday they bound the ends with liana to prevent it splitting and occasionally put mud on the thinner parts to prevent further burning. The work was completed before dusk. The canoe would cool gradually during the night, and in the morning the braces would be removed and replaced by flat wooden supports.

The sun shone warmly on the russet water as Kuarumey paddled a slim canoe away from the port and down the river – so light, so strong, so manageable and in shape so beautiful, yet for ourselves unthinkable – we would have capsized in a moment; only Horacio could master an Indian craft. *El Diablo* was now on the bank drying in the sun, and Horacio and José were starting to recaulk the battered shell.

It was cold and wet when José and Uriel left early next morning to take a load of equipment ahead. Mist hung low over the forest and the trees dripped with moisture. 'This is white rain,' said Horacio. 'It is more usual in the winter months, so perhaps we are due for a wet spell.' Without José we had no means of talking to the people in the *maloca*.

Suddenly Kuarumey's wife ran out and grabbed Brian's arm, beckoning him to follow her inside. From the far end of the dark interior, behind the palm screens, came strange sobs. It was Watsora whose husband had been away on a hunting expedition for nearly a week. Her naked body, lit only by a dull red glow, was doubled up. She heaved and hardly seemed able to breathe. Only the day before she had carried her heavy basket of manioc from the plantation. Now her thin, drawn face, her sagging breasts, her dishevelled hair, aged her beyond belief. A young girl clutched her around the waist and moved to and fro with the heaving figure, quietly chanting to herself. Watsora's baby son ran to his mother's side and clasping her arm began to cry.

Kuarumey's wife implored us to help. She pointed to the black medicine chest. Only the previous night we had given the headman aspirin, but this illness seemed much more serious than a headache. We could not be sure

47

PLATE 1

Txukahméi woman and child with
painted bodies. Xingu, Brazil.

what was wrong. Perhaps she had an internal haemorrhage, maybe it was consumption, or was it appendicitis? We couldn't know, none of us was a doctor. Horacio was firm: 'No, we must not give her any drugs, for if she dies, then what do you think will happen to us?' For a time we argued but eventually agreed. Horacio was right: no matter what we felt, we could not afford to be held responsible for her death, nor could we interfere.

The wails increased, the young girl's chant grew louder as she repeated the same notes over and over. The atmosphere in the *maloca* became unbearably tense and, while Horacio read outside, we went down to the river, trying to escape a situation which we could do nothing about. When Horacio's drawn figure appeared walking slowly down the sandy track, we could guess what had happened.

'Watsora died five minutes ago,' he said and went back up the path. We said little and silently followed him back to the *maloca*. On the way we passed Kuarumey's old mother. Her normally jovial face was now serious. She avoided our eyes and continued to feed her toucan with beetle grubs. Inside all was silent, the boat was downstream and we had no means of talking to anyone. The tiny black sandflies converged on us in the stifling heat of the early afternoon. A woman came over to our equipment, undid a tin and took out a handful of rice, looked at the grains, smelt them and then carefully poured them back again, wiping her hands on a kitbag when she had finished.

Returning later we noticed that the earth in the centre of the floor had been disturbed and fresh yellow clay lay on the surface. None of us had actually seen the corpse, but Donald had seen the young girl, who had been wailing at Watsora's side, take the dead woman's hammock down to the river and wash it. Later we learnt that the Tukano always bury their dead inside the *maloca*. The method is much like that of the Noanamá and the highland burials of the ancient Chibcha. They dig a trench and excavate a horizontal vault about three feet beneath the surface. The corpse, with the knees bound to the chest in the foetal position, is wrapped in his own hammock or in barkcloth and then inserted in the vault which is blocked with leaves, so that earth never touches the body. With the body are placed private possessions: pottery or a basket in the case of a woman; a bow and arrows, coca pouch or snuff-shell in the case of a man. They retain these possessions for the afterlife, the happy hunting grounds where they will travel in spirit.

No ceremony could have taken place in so short a time, and the women continued to make cassava, as though nothing had happened. Before the death they were wailing, now they were silent. The people who had once been so ready to smile, the children who normally followed at our side, were aloof and distant. Each one of us was tense and worried and it was a relief when a new face came to the entrance of the *maloca*. He seemed familiar and we recognised one of the Indians we had first met on crossing into the headwaters of the Piraparaná. He was returning home after leaving his baskets of *farinha* on the Río Ti and offered to take some of the equipment downstream in his empty canoe. The offer was accepted.

'There are *jakaratinga* in a small creek near my maloca,' he said in broken Spanish, 'and I want to borrow a shotgun and a torch to go and shoot one tonight.'

We had heard that this type of baby crocodile was good to eat, and this was another chance to restore the Indians' confidence in us. With a certain

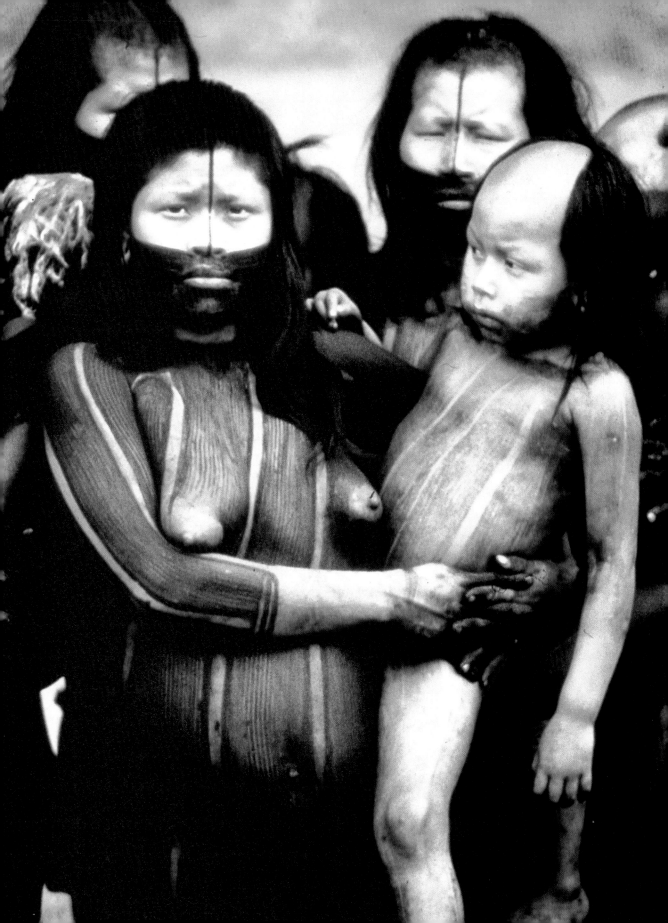

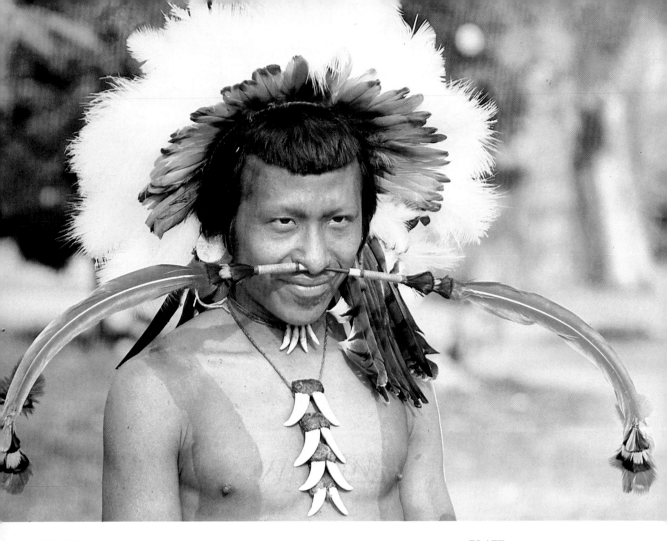

PLATE 2

An Erigpactsa (Aripaktsa) man
wearing a macaw and toucan feather
nose ornament and a feather
headdress. Juruena river, Tapajos-
Madeira, Brazil.

PLATE 3

Barasana man painting the front
of a *maloca*.

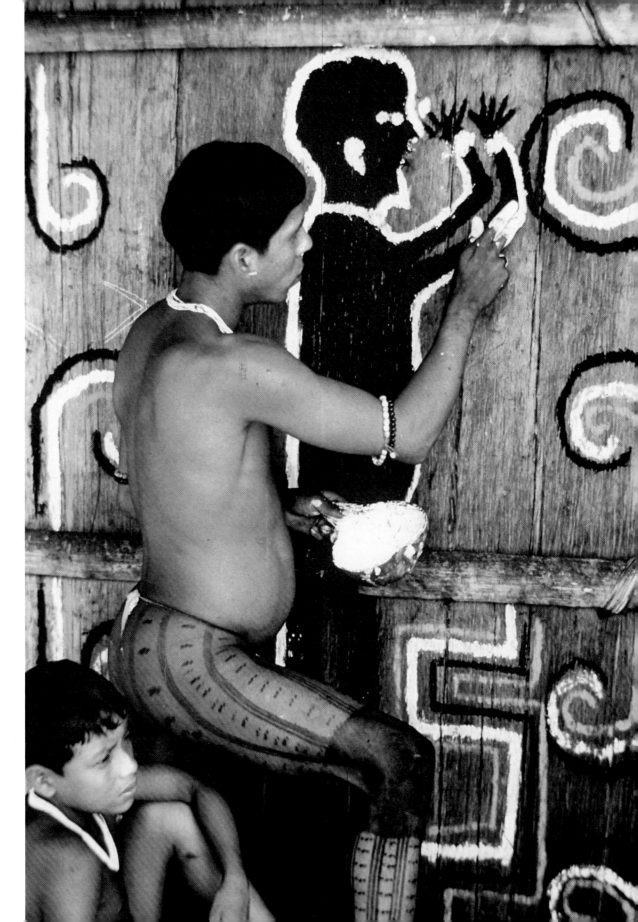

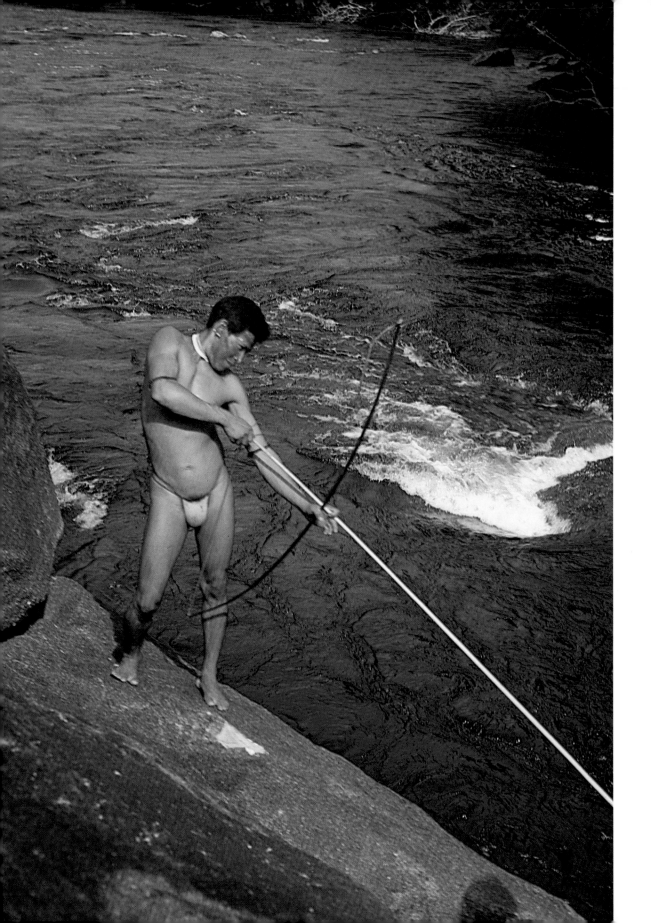

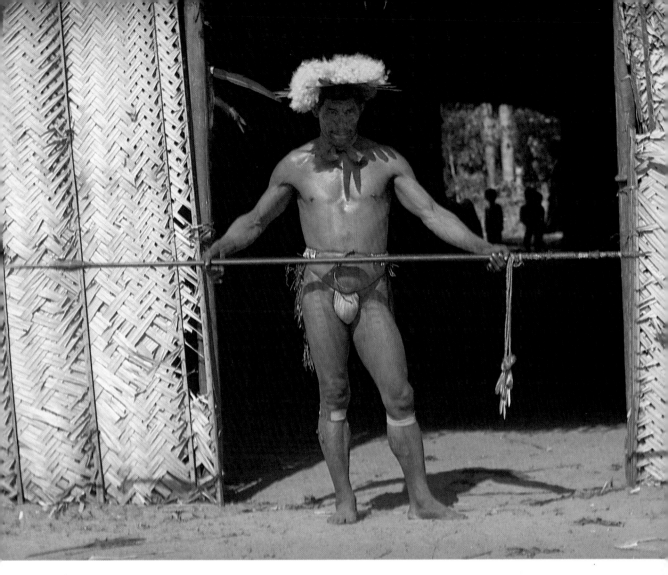

PLATE 4

Taiwano man shooting fish with a
long fish arrow (see page 64).

PLATE 5

A Makuna shaman in festival
regalia holding his rattle-spear.

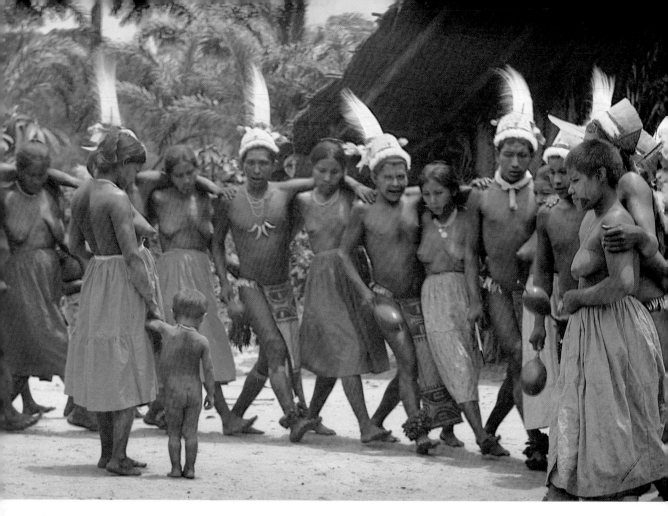

PLATE 6
A Makuna festival dance.

PLATE 7
A Makuna boy wearing ceremonial
headdress and holding panpipes.

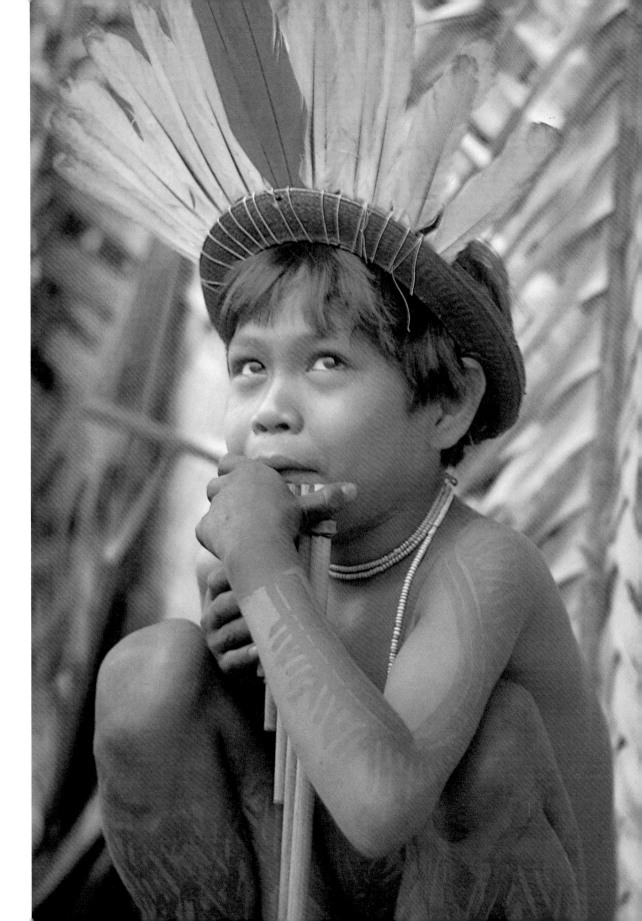

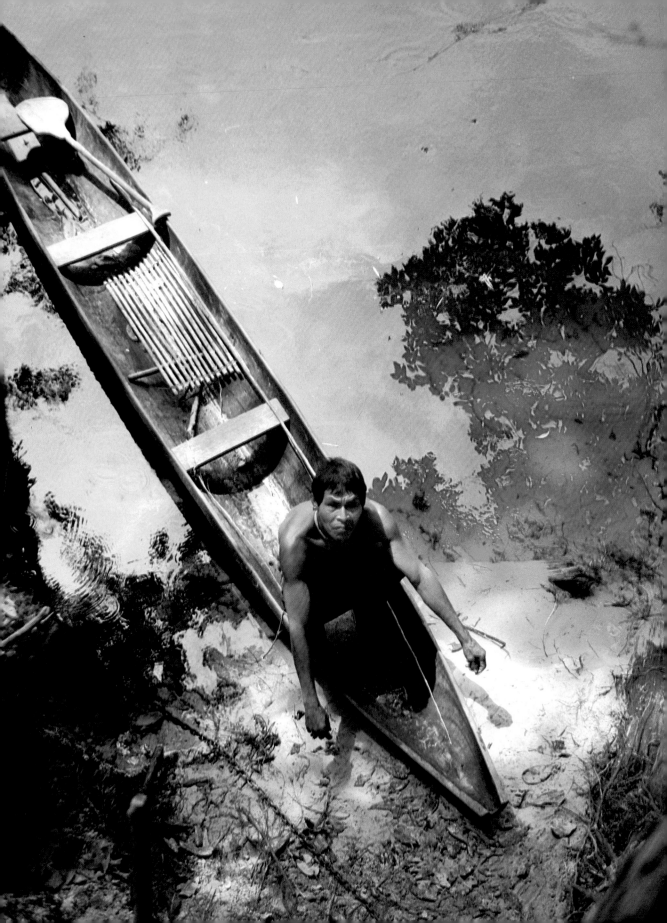

PLATE 8

Man seated in a Tukano
dug-out log canoe.

reluctance Donald lent his twelve-bore. Now only Horacio's ·22 remained. We always had to rely on their help. If they looked on us as friends, they would not steal our guns. If they did not, they could kill us just as easily, whether they had our weapons or not.

That night the men squatted on their stools, around but not on the patch where the woman was buried. As they chewed coca, they mumbled at times in answer to Kuarumey. Several times one of his younger brothers left the group and came over to our hammocks to look inquisitively at our kitbags and finger them, his solemn face caught in the failing light of the torchwood.

It was still raining the next morning. Without any warning, Kuarumey stalked out of the *maloca* leaning on his stave, looking neither to left nor right. Some moments later two men followed him down to the river, their paddles on their shoulders and coca pouches slung across their backs. They were taking Kuarumey to the shaman who lived deep in the forest below the Piña *cachivera*. An old man sat humming to himself in front of the palm screen where Watsora died. Here was an opportunity to make a unique recording, but it was not the time to upset the Indians.

With dusk approaching, José and his brother walked up the path from the river. They carried nothing and José seemed ill at ease while Uriel remained silent. Over the evening meal we told them that we would leave early next morning and that our intention was to descend the Piraparaná, then the Apaporis, and eventually arrive at La Pedrera on the Caquetá. To return to Mitú was now out of the question. Up to now José had thought we were going to return to Mitú and he greeted the new plan with apparent enthusiasm. Still we could not be sure of his intentions. When they went back to *El Diablo* to collect the gun and their own belongings and did not return after an hour, doubts once more entered our minds. Horacio left for the river carrying his rifle and we followed, but our alarm was without foundation – we met our guides as they were coming back along the path. By dawn the next day we had left the *maloca* and Kuarumey had not returned.

Below Kuarumey's the river was wider and deeper – deep enough to use our diminutive 7-h.p. Johnson outboard motor. Frequently during a day's journey we would come to rapids or a fall where everything had to be removed from the boat and carried to a point where it would be possible to reload. Then, using ropes, slithering over the rocks, pulling, pushing and heaving, we would get the empty eight-hundred-pound shell over the rapid sections. Sometimes the canoe seemed on the point of being swept away to destruction, but José and Uriel, together with the Indians, who for the small reward of beads, a piece of cloth or nylon fishing line were always ready to join us, seemed to know exactly how to manage it, though much bigger than their own light and portable craft.

During the severer overland passages the canoe might get a bad knock, and in spite of the recent overhaul it would be necessary to do more caulking. Sometimes, in despair, we doubted whether the old boat would even reach the Apaporis before she finally gave up and sank. To return the way we had come – which had been our original intention – was out of the question. Our only way out was to the Caquetá, a major tributary of the Amazon. What this journey would entail we could not imagine, for all the maps we possessed had often proved incredibly inaccurate. Of the time it would take us and the route we knew nothing. We had, however, heard that the lower

reaches of the Apaporis were impossible to navigate owing to a series of great falls and rapids. This knowledge certainly gave us cause to worry during the ensuing weeks.

At this stage we not only had to travel down the river but also to return up it, as we still had too much equipment to take at once. Normally José and the Indians would travel downstream for several hours with the equipment, then return for us. It was on one such journey of José's that the outboard started misbehaving. It was too late to do anything when the engine finally stopped and refused to restart. So the next day we continued paddling down river in a very despondent mood – the thought of paddling our way to the Caquetá was not a happy one. The best we could do was to make for the next *maloca* and if possible effect a repair.

We arrived at the *maloca* that afternoon. Not a single Indian was within sight, not even a dog. At first we assumed the house had been abandoned, but a smell of wood smoke lingered. Puzzled, we noticed the fires had only recently been left. This was the first time we had encountered such a breach of hospitality, for the Indians must have known of our approach. We assumed however, they would return at nightfall, so we set about hanging our hammocks and preparing our beans and rice.

The Indians did not return that night or the next, and the deserted *maloca* seemed strange and forbidding. Horacio was certain that these were unfriendly Indians and that this was their way of showing it. We should therefore be cautious and move on as soon as possible. But the broken engine enforced a stay. We tried wood, then Perspex to replace the broken clutch sleeve, and it was several days before we found that a section from one of our aluminium eating plates was the answer.

One day, while we were waiting in the deserted *maloca*, we were suddenly surprised by shouts. Outside a fierce-looking Indian with a carved redwood club in his right hand stamped and grunted his way round the bare sandy ground in front of the *maloca*. He was followed by three younger men, each carrying a machete, all with their faces covered in red warpaint. Then suddenly and silently he and his small band of warriors departed to the river, to their canoes, back to their own forest home.

It was with some relief that we set off again from the deserted *maloca* to continue downstream. At night we would clear an area near the bank for a camp site, put up the tarpaulin for the equipment, then sling our hammocks to the nearest trees. If it started raining we would have to huddle under the tarpaulin till dawn. It was much pleasanter when a *maloca* was close by at the end of a day's journey, as there we were assured of warmth and a roof over our heads.

During the course of our journey we visited fifteen *malocas*; in some we only stayed overnight, in others several days. They extended a distance of about 250 river miles – from Kuarumey's to the last rapids on the Piraparaná, about 100 miles from its mouth.

Though at times we were angry with José for always hustling us on with threats of desertion if we did not continue downstream, it was for the most part only through him that we could talk to the Tukano: only those who had worked rubber knew any Spanish. It was during these visits that we became better acquainted with the Indians, though they remained remote, perhaps because they distrusted us, true 'Sons of the Forest,' their personalities hidden as deep within themselves as they were deep in Amazonia.

The Tukano are small: a man rarely exceeds five foot six and the women

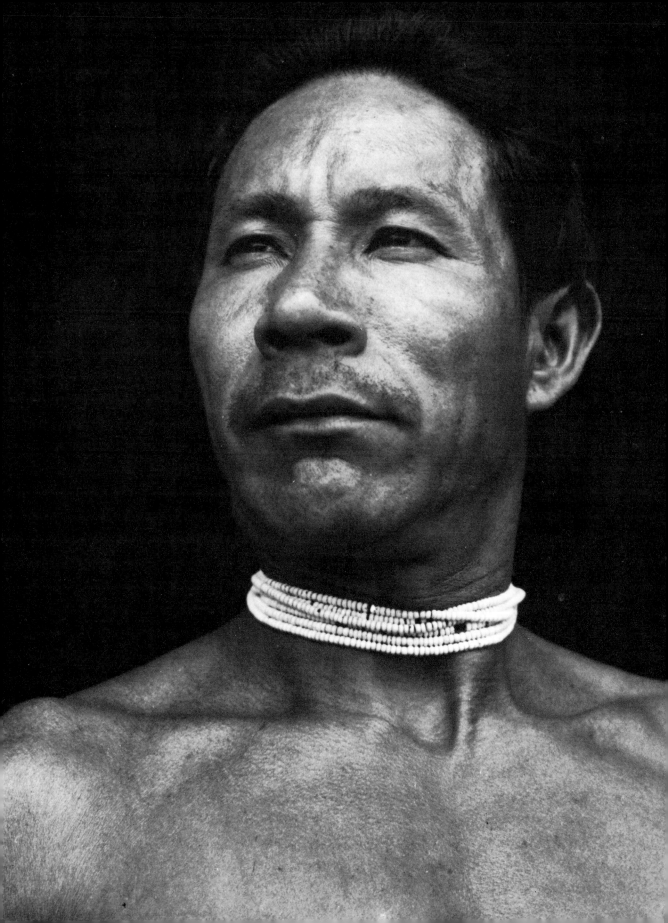

are often no more than four foot ten inches. To see a cripple or deformed person is unusual. They are healthy and immensely strong. A man wears no more than his loincloth, today cut from a piece of trade cotton but formerly a strip of beaten barkcloth. Around his neck are three or four coils of minute white porcelain beads, which are among the most valued objects of exchange; a tight string of black berries is strung on *cumare* palm fibre above each elbow. The ears are often pierced with a short cane jutting out from the lobe; sometimes a feather is put into the cane, or a flower replaces the ear-plug. With their short, cropped hair and well-proportioned bodies they stand out as strong figures, beautifully adapted to the forests in which they live.

Their gait is jerky rather than slow and relaxed, indeed they almost run; whether the Indian is out hunting or carrying heavy loads he always moves in the same way. We could only look on amazed as our fifteen-gallon fuel drums were carried for two- or three-hour stretches with no apparent difficulty. They only showed any signs of wilting in strong sunlight; an Indian would rather travel by night than on an open river in the midday sun; his home is in the cool forest or under the dark eaves of the *maloca*. His face painted red with *karayuru*, a bow and a quiver of curare-tipped arrows in his hand, he has little sympathy for strangers and would rather remain undisturbed. It is therefore not surprising that the Indian's face tells you little. When he stares at you with his black eyes, it is as though you were peering into the cold unknown, and there is little warmth in his expression. We very seldom noticed any demonstration of affection among the older people. Husband and wife live together rather as a matter of arrangement than through love, and tenderness was only shown to the younger children. The old people, once unfit to go out hunting or to work in the plantation, may be neglected in times of shortage and even left to die. They are no longer of any use to the society, so it is best they go; theirs is a harsh world where only the fittest can survive.

Although the Tukano seem outwardly reserved, lacking in affection and often proud, they are invariably very courteous. Their greetings are formal – just as we shake hands they always exchange a lengthy stream of words. It is as though the visitor to a *maloca* is explaining his reasons for arrival while the host answers him in short phrases of affirmation. They do not look at each other during the greeting, no matter whether they are in a *maloca*, on the river or in the forest. We were continually impressed by their simple yet perfect manners. Cassava and perhaps a newly-caught fish would be brought to us when we first arrived at a *maloca*, then, without our asking, we would be shown where we could sling our hammocks.

The men have an easier life than the women. Their short, clipped speech has, like their gait, a matter-of-fact sense of urgency about it, but is punctuated by high trills of laughter when they joke and make fun amongst themselves. They are born with a sense of humour, and it is the old who suffer at the hands of the young. In one *maloca* a little boy consistently refused to let his grandfather take his afternoon siesta. To everyone's great amusement he would tickle the old man with a piece of grass, pretending a fly was settling on his body.

It would be impossible to say whether the early push of the Jesuits up the River Amazon towards the end of the seventeenth century, and the more recent incursions of the *caucheros* and the Roman Catholic missionaries on the Vaupés and Caquetá, have had an influence on Tukano thought. Certainly

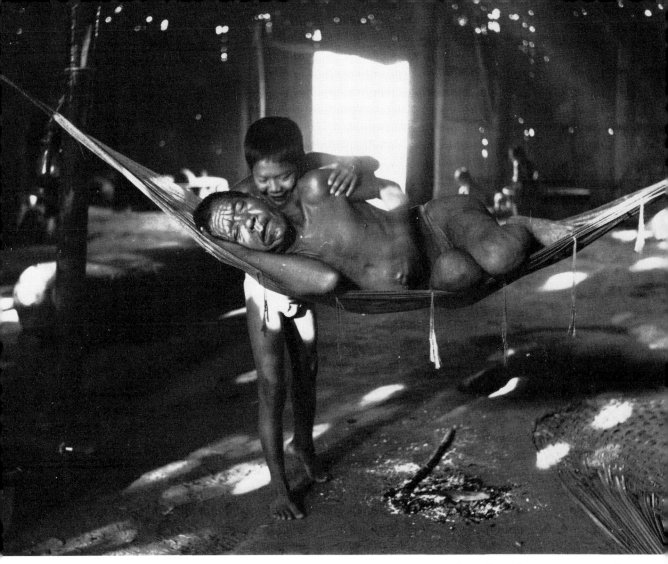

The interior of a Tukano *maloca*: an attempt to take an afternoon nap.

their beliefs are very complex. Moreover, the Tukano live in an area as far from the Amazon as the Hebrides from London, while the first direct missionary contact with the upper Piraparaná had been made by Padre Elorza only the month before we arrived.

Besides believing in some vague all-powerful good spirit or god, the Indian believes in many lesser spirits, both good and evil, all of which have a great influence on him and to a large extent rule his life. The good spirits can be recognised in the pleasant things of the forest. They are represented by fruit trees and plants – bananas, pineapples and other edible fruits, and coca too; the various trees used in making the *malocas*; the cool and clear forest streams. Whereas the poison in manioc, the twisted creepers and roots which trip weary hunters, and the jagged rocks in rapids which split canoes – these are evil spirits.

Apart from this animistic belief, the Indian believes in an immortal soul – at least in some cases, for he acknowledges the existence of spirits of the dead, usually his ancestors. The spirit of a living man wanders only when he is asleep. The shaman on the contrary can divest his body of the spirit at will and glide through the jungle in the guise of a puma.

Usually the men are called after birds, and the women after plants and

flowers, but when asking a Tukano his name we would be given a Spanish one or nothing at all. Possibly the reason for this was that by saying his name aloud an Indian might call back the spirit of an ancestor who had the same name, or worse, by telling us he might have given us power to work evil over him. Incidentally they would usually ask ours, which we would give them – to their obvious amusement, possibly owing to the strange sound which they would find almost unpronounceable.

An Indian will show a stoical indifference to a wound in fighting or an accident while hunting. Yet when suffering from a less obvious ailment an Indian is often convinced that someone has worked evil on him. Should death occur, his relations must seek revenge on whoever is responsible. On the occasion of Watsora's death our own position was extremely unsure, particularly when Kuarumey departed to visit the shaman.

It seems in retrospect extraordinary that we were ever allowed to continue our journey. For the shaman once consulted has to find a victim on whom he can place the blame for an ailment or death – in this case both, in the same house, the one in which we were guests. What better subject could he have had, the visiting white man, regarded with suspicion by the Indians, and uninvited? Barely two decades earlier the Indians of the Piraparaná showed no compunction in killing *caucheros* who interfered in their lives.

Perhaps the most noticeable thing about Watsora's burial was the speed with which she was buried and the fact that this was done within the *maloca*. This could be accounted for by the fear that the body might be whisked away and eaten – some of these tribes were once cannibals – and then the spirit could never escape to the afterlife. Also, once buried, there was no indication as to where they had placed the body.

Like most of the Amazonian tribes the Tukano have no real central authority or clan cohesion. The authority, such as it is, is invested in the heads of families. These composite families seldom number more than twenty to thirty people, usually far less. Even the head of the clan or family has only a semblance of authority, though there are exceptions, and often less power than the shaman. This lack of leadership combined with a preference for isolation – which may be partly explained by the environment in which they live – has resulted in the small unconnected settlements typical of the Indians of this region.

A headman is responsible for the provision and organisation of the household. He arranges the building of the great *malocas* when it is necessary to move. He also oversees festivals and councils. In some households his actual power appeared to be slight, and it seemed to us that the average Tukano did more or less exactly as he pleased.

In the event of a headman dying, a festival is normally held in his honour after the burial. A new headman is then elected, usually the eldest son of the chief, though this decision depends on the council of elders of the household.

If the headman is the secular authority, the shaman is responsible as a spiritual one, in that he is always counteracting the influence of the evil spirits. He also cures the sick and diseased and in the event of death names the person responsible, so that revenge may be exacted. Living in a world apart, he keeps somewhat aloof from his fellow tribesmen and to enhance this sense of separation he may wear distinguishing marks.

Tukano families are small, there are seldom more than two or three children. Why more do not survive is difficult to explain, but life in the Amazonian forest is rigorous and the Indian believes that if a child cannot

stand hardship at the moment of birth, it will not be able to stand that of later life. The normal custom of washing the new-born child in a stream is sometimes fatal. Moreover, should the child have any blemish or disfiguration – signs of evil to the Indians – it is all too easy for the mother to hold the infant beneath the water till it drowns. Should she have twins, this will also be the fate of the second-born, or it will be left in the forest to die. For to have more than one child at a time is to be like the animals of the forest – a terrible disgrace. In some *malocas* a dearth of children was very noticeable, especially in the lower areas of the river where the *caucheros* had greater influence.

The children assume adult responsibilities at a very early age. When we were waiting in the deserted *maloca* we noticed a small thatched shelter close to the women's entrance. It was bare and empty, and Horacio told us that this was probably a menstrual hut. They were common among the tribes in the Llanos and the women also retired to them during childbirth. Perhaps the Tukano had the same custom, but we learnt no more.

We saw no puberty rites though we did hear of a ceremony called Jurupari. At certain seasons in the year the men leave for the forest to collect baskets full of chrysalises, *mojojoy*. When the women hear the men returning to the *maloca* they run screaming to the nearest plantation. Here they remain while the ceremony takes place, for they believe that the men have brought Jurupari, their god, with them, and if they or their children should see him, they will die. The men play long seven-foot flutes. One of these trumpet-like instruments, the largest of all South American flutes, was later obtained by a friend and given to us to bring back to England.

While the men are alone, they carry out a trial of strength to establish the strongest members of the clan. Each man scourges the other on the back, between the head and the waist, with whips made from lianas and monkey hide. There is no fighting, but the women become more and more afraid as from the plantation they listen to their men's cries. With nightfall the sacred Jurupari flutes are carried away from the *maloca* and buried underwater in a secret stream bed. The women and children can return now, and they dance and drink *chicha* throughout the night. The feast is open to everyone. It is said that no outsider has ever witnessed this strange masochistic ceremony which is the nearest thing to initiation known among the Tukano.

As a boy grows up, he takes his place with the men. He has his own bow, arrows and curare. He takes cocaine and can wear the full feather headdress in the tribal dances. He soon chooses a wife from a neighbouring clan, and brings her back to live in his headman's *maloca* and share in the work of the plantation. Though the headman may have two wives, monogamy is the normal rule. Should a young man wish to be independent, he may leave the house of the headman and go off into the jungle to cut his own *chagra* and build his own house.

Unlike many of the Amazonian Indians who live in village communities, the Tukano live isolated in their *malocas*. A *maloca* is the only centre of human life for miles around, separated by a clearing from the surrounding forest and placed sometimes a mile or more from the river, away from the sandflies, mosquitoes and other insects that plague the banks, and from the prying eyes of enemies and strangers. The only signs of life are the moored canoes, and it may be as much as an hour's walk before the *maloca* is reached along a narrow, almost indiscernible path, which at times seems to fade away into nothing – as indeed it is meant to.

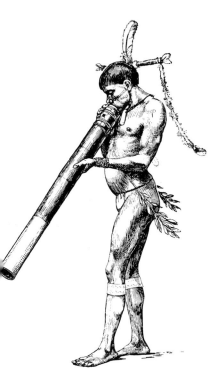

A Tuyuka man playing a Yurupary trumpet. Among the Tukano these trumpets represent the spirits of the ancestors and are to be seen only by the men.

A *maloca* is built to vast proportions, often eighty feet from end to end and sixty feet wide, with the ridge of its roof thirty feet above the ground. This ridge is supported by six great posts, three on either side; the central space extending down the length of the *maloca* is like the nave of a church. The roof is thatched with palm fronds overlapping to a depth of four inches and extending almost to ground level on either side. These fronds may have to be brought from a great distance and vary in quality – the best lasting for years, while others rot quickly and require frequent patching.

As the sun rises each morning over the surrounding forest it lights on the striking clay and charcoal designs which are painted along the whole width of the front wall. Slivers of light find their way through the palm screening and form patterns on the floor and the walls inside. The only other light comes from the men's and women's entrances at opposite ends of the house, entrances which are often kept shut to discourage the flying insects that are usually at their worst during the middle of the day. From these doorways bars of sunlight cross the hard earth floor, lighting the main posts of the house. Beyond, just discernible, is the *chicha* canoe, the great vat which quenches the thirst of the dancing guests at festivals. Near by stands a forked pole where hang coca pouches, fruit-husk ankle-rattles and fret-worked gourd *maracas*. On the floor are calabashes some with coca inside, others with tobacco, and the wooden stools on which the men squat, passing half the night over their stories of past deeds in tribal wars and great hunting expeditions.

Overhead the smoke-blackened thatch is hidden in the gloom. Hanging from a beam is the most treasured possession: the barkcloth-covered palm box containing ceremonial feathers, monkey-fur belts and puma-tooth necklaces – all the precious adornments for the tribal dances, the greatest occasion of all in the lives of the Indians. The palm-woven screens, which divide the quarters of the women and the head of the house from those of guests, reach from floor to thatch. Near by are the great, flat, pottery cassava ovens. Hosts of baskets and *cumare* hammocks are strung from the house posts around the fires, and the hard earth floor is kept spotlessly clean by thousands of tiny scavenger ants.

Why the *malocas* should have been built on such a vast and gloomy scale remains a mystery. It is possible that their very size gives the Indian a sense of protection from the surrounding forest. It may also help to keep the interior cooler. But it is most likely a sign of depopulation, the breaking up of the clans through rubber exploitation and disease; where once a hundred or more people lived, now there are twenty.

Slowly the great house comes to life. Smouldering fires are stirred into a blaze, for the hour before sunrise – even inside the *maloca* – is always the coldest. A baby cries, a young Indian moves from his hammock to the palm-screen door and eases it up to its hook like a portcullis, then saunters leisurely out into the dawn. Others follow. The women move at the far end of the *maloca*, still only vague shapes in the gathering light as they prepare cassava, pick up the water pots and go down to the river to bathe.

The men returning from the river squat on their haunches on the low stools in the centre of the *maloca*, and without any ceremony consume their breakfast of cassava bread, manioc juice and probably some leftovers from the previous night – boiled fish or a piece of bush pig. The women, who have eaten separately with the children, collect their large manioc baskets and leave for the *chagra*, the forest clearing where they grow their crops. The

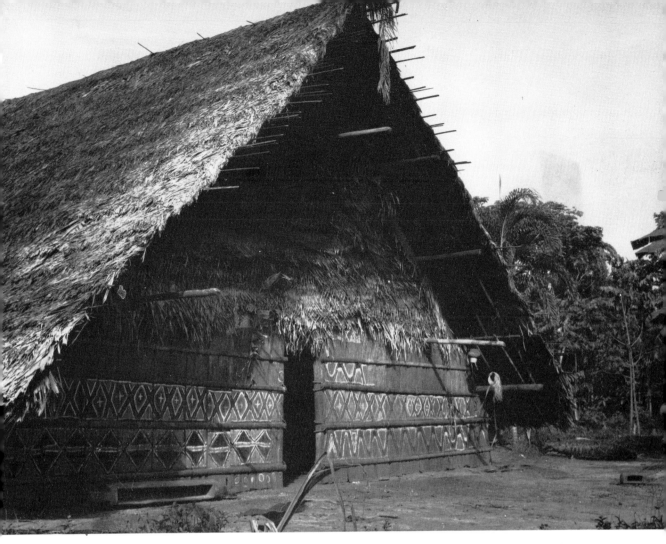

A Tatuya house with thatched roof and geometric designs painted on the bark wall at the front with clay and charcoal. Colombia.

A page from one of Donald Tayler's field notebooks showing plan and elevation of a *maloca* and details of its construction. Apaporis River, Colombia. 1961.

baskets are slung from a strip of sapling bark across the forehead; they hold their babies on their hips, walking rapidly, almost awkwardly – the Indian woman's gait is not a graceful one. Children run along beside them, some affectionately holding the hands of their mothers, others playing. A few of the elder children return to the river to fish, and some of the men go off in pairs to hunt and fish, while others collect coca leaves from their *chagras*.

The Piraparaná has always been an area of coca cultivation and today the river and its tributaries are one of the few remaining strongholds of the drug in north-west Amazonia. Carrying no more than their small coca pouches and the basket for the leaves, five or six men, led by the headman, go down to the stream, perhaps taking a drink and washing themselves before they climb up the far bank. They move along a path through the thick vegetation of an old *chagra* fallen into disuse. Although an occasional banana or *pupuña* palm survives, the cultivated plants have been strangled by weeds and secondary growth.

The *cacique*, the *maloca*'s pet bird, accompanies the Indians, flying from bush to bush and cawing raucously as she glides low over their heads, her olive-green breast almost brushing their hair. She perches on a charred tree-stump, looks at them as they leave the old *chagra* and enter the forest, gives a loud 'caw' and flies back to the *maloca* to see what edible scraps can be found.

In the early morning the tall forest is dank and cool, a place of silence broken only by the occasional chatter of the Indians as they move rapidly along, their sure footsteps delicately gliding over the mass of roots which forms a base to the pathway. Few birds and no animals are about; the sun's rays piercing through the thick leaf vault give life to what might be a dead world. Suddenly they come to a wide expanse of cleared land. There is a chaotic mass of fallen trees, black from recent fires, surrounded by the forest wall. It is as if a great explosion had occurred leaving behind only the charred remains.

Every year or two, when the dry season comes in late November or December, the men cut down an area of forest, and about two months later, just before the rains return, they burn the fallen timber to make a new *chagra*. With each new *chagra*, the men, who do all the clearing and burning, move further afield, so that eventually, after some five years or more, the *maloca* too will be moved to be near the plantation.

This system of shifting agriculture, the men as it were preparing the ground for the women to work on, is carried on incessantly. Partly owing to soil exhaustion, partly because of weed strangulation, the areas of cultivation must be constantly changed, and so the moving Indian population covers wide areas of otherwise untouched Amazonian forest.

It is now January; the smell of the fire still clings to this battlefield of black charcoal. Soon, with the arrival of the rains in March, the women will plant out the manioc cuttings and by late October the first crop will be harvested; so for two years they may expect to get reasonable manioc yields from their *chagra*, after which they must move again.

The men run over the fallen tree-trunks and from the new *chagra* they move into an area partly overgrown by weeds and secondary growth. Here, placed almost mathematically across the *chagra*, in contrast to the haphazard cultivation of other plants, are the avenues of coca shrubs.

Perhaps the ritual associated with the taking of cocaine during festivals and tribal ceremonies, apart from its daily use, explains the attention given

not only to its later preparation but also to the planting and picking of the leaves. The common coca shrub, always tended by the men, stands about five feet high when fully grown and may last five or more years. It is the most important of the stimulants taken by the Tukano, some of whom are heroin addicts taking as much as two ounces a day. Their life is partly geared to their addiction, and their daily practice is to come to the *chagra* and spend the greater part of the morning collecting the leaves which they prepare during the afternoon and evening. It is a serious task and one which each man undertakes with a strange air of concentration. Each coca plant is selectively stripped leaf by leaf before the next one is tackled. The headman carries the basket with him and gradually it fills with handfuls of pale sage-green leaves. The younger men collect the leaves almost reverently in their right hands before emptying them into the basket, their faces serious, their crouched bodies shining in the strong morning sun, their short, clipped speech broken occasionally by a high-pitched laugh.

In the distance small ribbons of smoke rise in a misty cloud. The women are just visible, their squat figures crouching among the manioc plants. They can be heard laughing; occasionally a baby cries and the children

Two Makuna (Tukano) men picking coca leaves in a *maloca* garden. Though most garden work is done by women after the initial clearing, men tend and harvest the tobacco and coca.

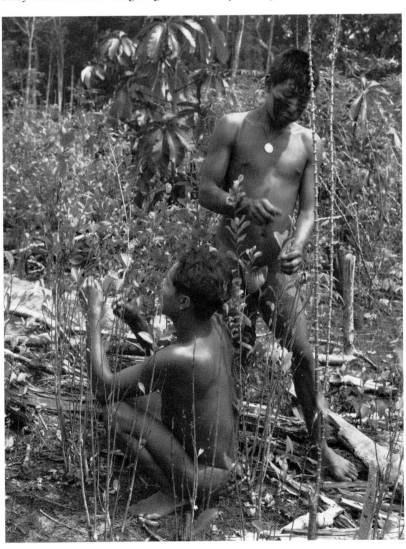

romp and play among the bright-green manioc plants whose tall spindly branches stretch skywards some six feet, terminating in clusters of long, thin, starlike leaves. With their babies straddled across their backs the women spend the morning cutting out the long potato-like roots from the sandy soil and putting the waste foliage into piles to be burnt. It is hot with the sun streaming down, the fires crackling and the smoke enshrouding the working bodies. There is little time for rest, though a woman will stop to swing her child around and let it suckle her breast; a mother may give a fat yellow beetle grub to her child to eat, having detached the head – a great delicacy, tasting like butter. Soon large baskets are filled with roughly peeled and half-cleaned roots.

The sun is high overhead and the men leave for the *maloca* with their basket full of coca leaves; on top they place large dried leaves from the *yarumo* (Cecropia) trees which grow like weeds in the *chagra*. The women too load their heavy baskets on to their backs, the headbands taking the greater part of the fifty-pound weight. The whole group hurries through the forest in silence, passing the old *chagra* where the headman's wife leaves the other women to collect pineapples, then down to the stream beneath the *maloca*. At this point comes one of the noisiest and most amusing incidents in their daily life. Not only the manioc roots are washed in the water but the babies too; the mothers vigorously shake their large baskets of roots, then stop to splash water over the backs of the children. For a short time there is

A Makuna (Tukano) woman and her baby bathing in a tributary of the Piraparaná river, Colombia.

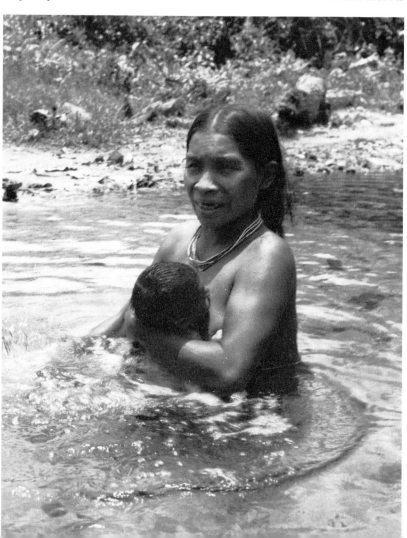

cacophony, with screaming babies, splashing water, continuous chatter and laughter, and even barking dogs. But soon the stream is left to myriads of white and brimstone-yellow butterflies which circle everlastingly over the sandbanks, and the women, refreshed, their long black hair glistening in the sun, return up the path to the *maloca*.

Tobacco plants are nearly always grown in a little patch directly in front of the men's entrance. Boys carefully pick the tobacco leaves one by one and lay them out on cane matting to dry. An Indian sits in the shade of the *maloca*'s overhanging eaves and starts to make string from strands of tough *cumare*. His graceful movements as he rolls the fibre with the palm of the hand on his shining thigh, the string looped around his right big toe, are like those used in the making of Venetian glass. An older man sits near by, deeply engrossed in the construction of a large, shallow cassava basket, a maze of cane strips almost hiding his wizened face.

The women file through their entrance, their great loads of manioc white and clean after their river washing. They pause for a moment or two and eat some cassava or the pineapples and wild fruit which they have just brought back, but soon they are working again, pulverising the manioc on the shield-shaped wooden grating boards which have minute flints or tough palm spines set into their baked-clay surface. They work as a team, some grating, others washing the manioc in vast basket-sieves slung between wooden tripods, while yet others extract the poisonous prussic acid by placing

After the manioc pulp has been washed it is placed in long tubular squeezers made of flexible twilled basketry. These have a loop at either end. One loop is fixed to a beam or, as here, to the top of a tripod. Downward pressure on the other loop forces the remaining liquid out through the basket-weave and the juice and water are collected below in a large container. Tukano, Colombia.

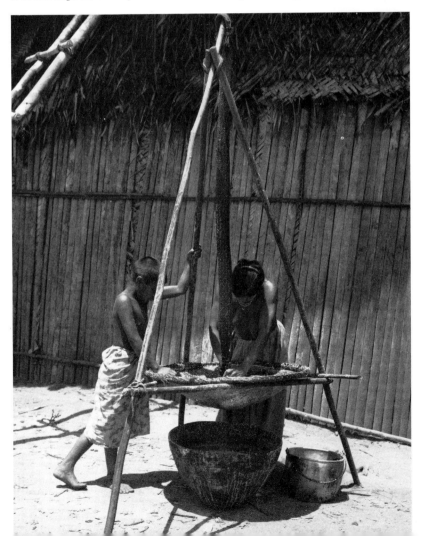

the grated manioc flour in a snake-like *matapí*, a long squeezer of plaited cane. With the upper end looped over a pole, a woman stretches its mesh by sitting on a second pole placed in the lower loop. The *matapí* contracts and the poisonous juice runs out.

When the flour from the *matapí* is ready it is placed on the large flat ovens to make rough cassava pancakes, the Amazonian daily bread, which they eat at every meal together with fish and meat brought back from the forest. The starch from the washed manioc is also baked to make wafer-thin toasted biscuits to add to the *chicha*. Some of the flour is spread thinly on another oven to make the nutty grounds of *farinha*, and the liquid from the washing and squeezing is boiled to neutralise the poison, then poured into the long canoe-trough to make *chicha*.

The noise of grating and the creaking of the tripods lasts all afternoon. A girl feeds her pet parrot some insects, then, taking a strand of *cumare* and winding it around her toe, she starts plaiting string for a hammock to replace her old one. Squatting on the ground, an old woman kneads clay and wood ash. She rolls the clay mixture into coils on a flat board and between the palms of her hands. Then she places them coil upon coil about a clay base, smooths the clay with a pebble and leaves the completed pot in the shade of the *maloca*. Later it will be put on a fire and surrounded with wood bark and ash to bake. Occasionally we saw an iron pot, which at some time in the past must have been traded up the rivers from the Caquetá or the Vaupés. These were sufficiently few to be highly treasured and hadn't affected their own pottery making, a craft which has been all but forgotten among many of the Indians of Colombia.

Throughout the afternoon the women continue with their tasks while the men prepare their tobacco and smoke it wrapped in long cylinders of banana leaf, or take snuff, lying in their hammocks or crouching on small wooden stools. The snuff, kept in gourds or large snail shells, is made in most cases from ground tobacco; it is first placed in the palm of the hand, then a small quantity is poured into a hollow V-shaped deer bone, and is injected into the nostrils by inserting one end of the V in the nose and the other in the mouth and blowing.

During the afternoon an Indian burns the *yarumo* leaves from the coca basket in the centre of the *maloca*, the ash being carefully raked into a neat pile on the earthen floor. Earlier the coca leaves from the basket had been baked in a large earthenware pot over a hot fire, all the while being stirred with a hooped stick. The toasted leaves were then powdered inside a short wooden cylinder. They are further refined by being put into a barkcloth bag wrapped round a heavy stick, and beaten inside a large cylinder. The *yarumo* ash is added to the finely ground powder and once again the mixed coca and ash is beaten in the long cylinder to the consistency of dust. Often this involved procedure goes on far into the night, and we became quite accustomed to go to sleep with the monotonous thudding noise still reverberating around the *maloca*. With the final process completed the powder is emptied into a half-gourd or into small barkcloth pouches, ready for the next journey or hunting trip, during which an Indian may live solely on the drug, going without sleep, food and drink for days.

The inscrutable nature of the Tukano may in part be due to his addiction to cocaine which deadens his senses and affects the eyes so that the pupils often appear dilated. This may also account for a lack of individuality among many of the men who often appear listless and resigned.[1]

A manioc grater of wood set with stone chips. The tubers are grated against the chips which are firmly glued into the wood and the pulp is collected in a basket or bark container. Tukano, northwest Amazon.

A manioc pulp squeezer of basketry.

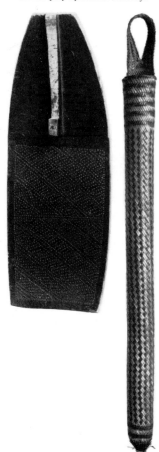

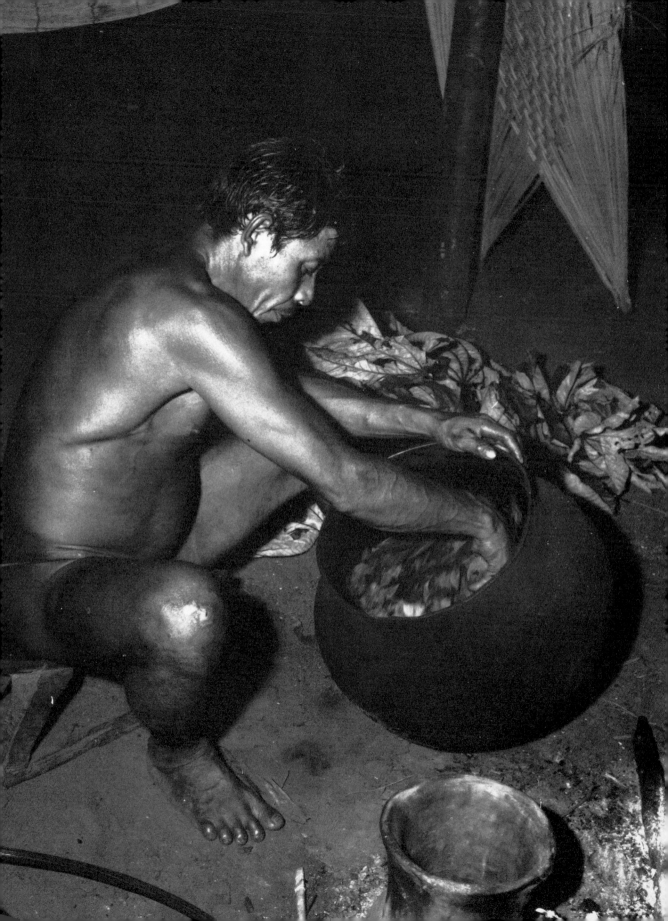

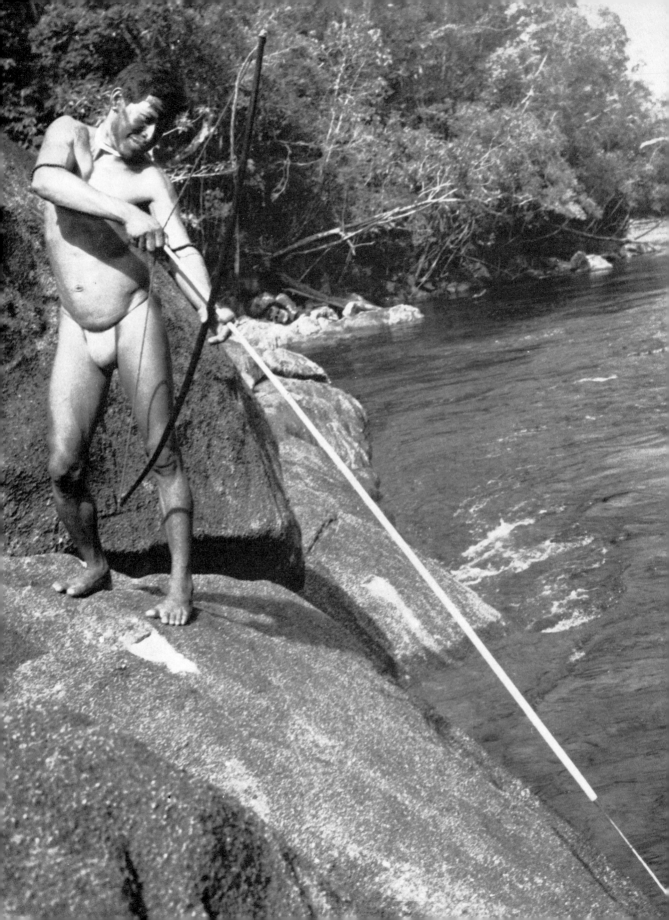

At dusk the hunters return and sometimes a monkey or a wild turkey
helps out with the evening meal of cassava. The only light in the *maloca*
after dark comes from the fires, but on special occasions, such as a festival,
the head of the house places a chunk of beeswax, taken from a wild bees'
nest in the forest, on a large post in the centre of the *maloca*, lighting it with
a firebrand. But the flickering light barely penetrates the gloom. At other
times a strip of slow-burning resinous wood is put in a fork of the same post.
It is this wood – a type of cedar – which the Indians use to travel with at
night, allowing it to smoulder and blowing it into flame when needed. As
night comes the doors are secured and, except for the sporadic mumblings
of a few old Indians squatting around the fires, all is silent.

The Tukano is a hunter. From his early childhood he develops the ability
to track wild animals in the forest and the sense of location and direction
which enables him to do this.

During the time we passed in their *malocas* the Indians would often dis-
appear in groups for hunting expeditions. Sometimes they would go at
night and ask to borrow our torches to dazzle their prey. They carry hard

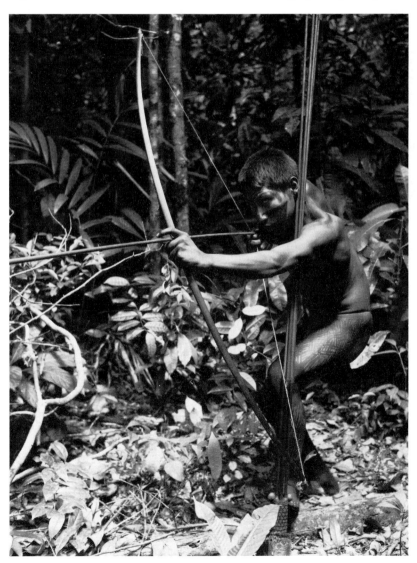

macana-wood bows and sheaths of arrows tipped with curare, a black strychnine poison, or a long ten-foot blowpipe. Also beautifully-woven palm cases filled with poisoned darts secured in kapok, as though stuffed into a pin-cushion. These are slung across the back and carried upside down with the beeswaxed end uppermost, so as to prevent the rain washing off the curare and to enable the hunter to extract the dart quickly. With the hunters go their dogs, thin wiry beasts like whippets, usually pale buff or fawn in colour and well cared for by their masters.

Their bows, five feet long and strung with *cumare*, will launch an arrow two hundred feet, but to be certain of a target the Indian will approach to within twenty or thirty yards. The arrows, without feathers and unnotched, are made of cane, with a hard *macana*-wood point dipped in lethal curare.

At that time we assumed that the Indians made their own poison, but we learnt many weeks later from a *cauchero* that there were specialists in this art.

The monkey is the most common of all the animals hunted for the pot, but the tapir is the largest of the forest mammals hunted by the Indian. It is the size of a cow, with a long snout, small eyes and slotted feet, and its only defence is camouflage. Speckled brown and black like the sun-dappled forest floor, when young, and turning to a dull slate-brown when fully grown, they gather at their watering places to drink. They were hunted relentlessly by the early rubber gatherers, who on occasion would shoot dozens at a time, more for sport than to supply meat. They are now nearly extinct in many areas.

The blowpipe is of as much importance to the hunter as his bow and arrow. The Tukano make their pipes from a small palm. The Indian will travel through the forest all day long, looking for game, carrying his match-thin ten-inch darts, perhaps thirty at a time, in wicker holders.

He constantly watches the trees overhead; he may suddenly see a parrot on a branch ahead of him. He moves forward slowly; if he can stand directly beneath the bird he has less difficulty in steadying his aim. He raises the pipe cautiously and places the cupped lower end over his mouth. He reaches behind with his free arm and draws a poison-tipped dart. Inserting it in the shaft with its cotton wad, he aligns the pig-bone sight on to the bird and inflates his cheeks. There is a barely discernible puff. Seventy feet over his head the parrot squawks, starts to fly, falters and crashes through the branches to the ground. Parrots are the most common target and the most easily approached, but unless cooked for many hours they are quite inedible.

In early February we started to make a small collection. For exchange we had brought rolls of coloured cloth, cigarettes, combs, thread and beads, fishing line and hooks. When we arrived at a *maloca* we would give presents to the headman and his wife, then to the rest of his family. There was never any hesitation in allowing us to sling our hammocks in their houses, but our giving gifts perhaps assured them of our friendly intentions. Moreover, in return they would often give us *farinha* which would help out with our own food. Of all the trade goods, small beads, and cloth especially in primary colours, red, blue and yellow, were the most popular. They preferred white beads and were prepared to exchange many of their own possessions for them. But even if we had lived with the Indians for some time, so that they knew us, they would have been loath to part with certain things. In order to obtain one of their magnificent head-dresses, which may have taken a man months to complete because of the scarcity of the feathers, we

had to give them one of our shotguns, nothing less. A shotgun was as good as a bow and arrow. For the Indian it had the advantage that you could shoot more than one bird at a time and it had a greater range than an arrow. But for years their gun would probably be useless because of a lack of shot and powder. Also the gun made a great noise and this frightened the game away. The only three we saw were ancient hammer guns, probably taken from *caucheros* they had killed.

In one of the last *malocas* of the Piraparaná we obtained a canoe. This proved extremely useful as it could be loaded with some of the lighter equipment, such as the collection, and towed from the back of *El Diablo*. Unfortunately it was narrow and unstable and on one occasion as we passed through some turbulent water, it swung sideways in an eddy and overturned. Before we were able to do anything several pieces of our small collection had already disappeared. As a result of this we learnt to keep an Indian in the stern of the canoe to guide it.

The rivers of the Amazon are usually termed black or white, to differentiate between clear and muddy water. Because of the amount of suspended sediment, white rivers are said to have many more fish. There were however a variety of fish in the 'black' Piraparaná. When we travelled on the river we would often see large gate-traps at the mouths of the smaller creeks. The fish hooks and line we carried for bartering were greatly sought after, though José for some reason sabotaged much of our exchange. He told the Indians that our nylon was not as good as their own *cumare* line and he broke the barbs of our steel hooks on the house posts to show that their own were better.

'That is barbasco, a poisonous liana,' José pointed to several bundles of saplings lying on the floor of a *maloca* we were visiting. 'Soon, in late February or March, before the first rains, all the Indians near here will gather for the fish poisoning. They will build small dams in the streams, and the *barbasco* will be pounded and thrown into the water above these dams. All the fish float to the surface and, with nets made from *cumare*, or long spear arrows with forked metal ends, they will be caught in great quantities and carried to a *maloca*. Usually a particular house is chosen each year and, when enough fish have been collected, the festival will start. This may go on for days with *chicha*, panpipes and painted *yarumo* dancing-staves, and many people – and more fish than we see at any other time in the year.

We came to the great falls of Beiju, and there, as we dragged *El Diablo* over the portage, we met some Indians who told us they were going to a festival at a Makuna *maloca* belonging to a headman called Bréo. It was two days' journey up a tributary, but we decided to go.[2]

The Tukano have many festivals throughout the year; among the most important are the Fish Festivals and the Harvest Festivals for the pineapple, *miriti* palm and *guamo* fruits, and for the manioc. At all these they dance, sing and play their instruments. But to the Indian, music is also a form of relaxation and enjoyment. Often as the men laze in their hammocks they happily while away the time playing on their bamboo panpipes. Blowing across the eight or nine-stemmed pipes two men may accompany each other for hours on end, ascending and descending the same scale, rhythmically counterbalancing one another in tuneful but repetitive melodies. They continue, apparently oblivious of repetition, and the panpipe tunes soon became imprinted on our minds. Each clan has its own variations; most of the tunes are based on their dances, though some are in imitation of

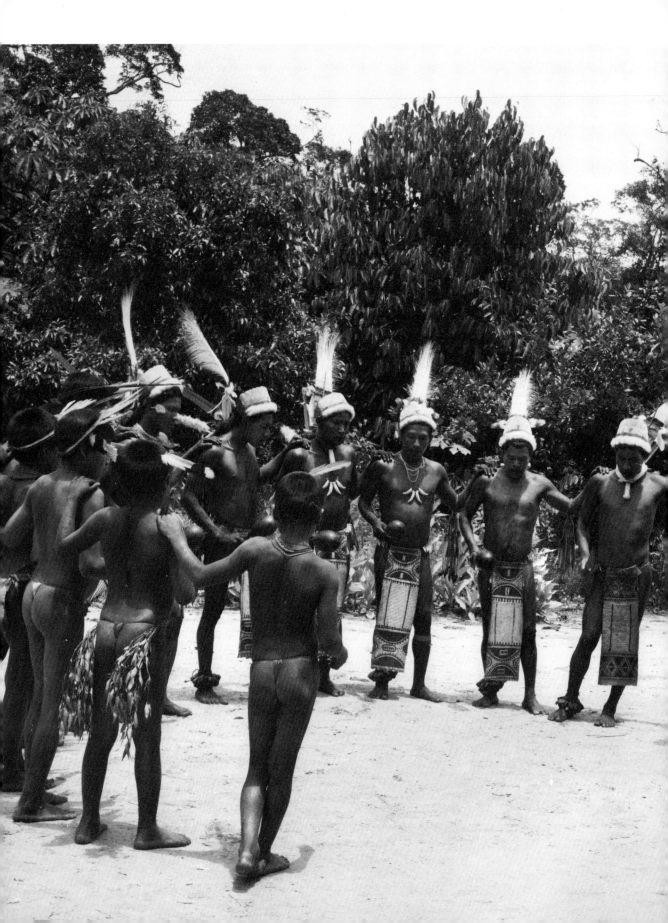

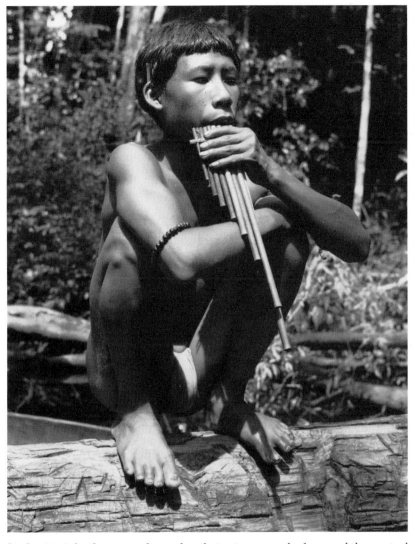

(*opposite*) Makuna men and boys dancing. Only fully initiated men may wear full ritual regalia. The younger men can wear simpler feather crowns. The dance 'aprons' are of painted bark cloth. Some of the men wear cylindrical quartz pendants, no longer made but much prized; others have boar-tooth necklaces. Bundles of aromatic leaves are tucked into the ocelot or peccary-tooth belts. The men carry *maracas* and each wears a jingle-rattle of nut shell on the right ankle.

Taiwano boy playing a nine-stemmed cane panpipe with stick ligature. Piraparaná river, Colombia.

birds. At night the young boys play their pipes crouched around the central posts of the *maloca*, and the clear notes carry across the still forest like church bells ringing on a cold winter's night. Only occasionally do the Indians actually sing for enjoyment; one headman uttered a staccato war song as he pounded coca leaves and occasionally the women hummed as they rocked their babies to sleep. Their instruments are more important to them; of these the snail-shell and deer-bone flutes, the tortoise shells and the clay horns are the most unusual.

It is hard to believe that a river-snail shell no more than three inches long can produce a most haunting tune. This tiny flute, the three-holed *sihoo*, is more often played outdoors than inside the house. Its clear rippling notes mingle with the forest calls, perhaps imitating a bird drawn closer and closer to the Indian hunter. The deer-bone flute, in contrast, has a harsh, piercing, eerie sound. It is made from a deer's tibia and three holes are drilled into the bone with a *capybara's* tooth. A little slit is cut into the head of the deer-bone, down which the man blows. Small lumps of beeswax are melted into the apexes and shrill notes come flowing out – bizarre perhaps, but melodious. This instrument is generally heard during the *chicha* cere-

Tukano man playing a *goo*, a musical instrument made of tortoiseshell and wax. The sound is described as 'hypnotic and melancholic' and is produced by rubbing the palm of the hand over the lump of wax at one end while holding the *goo* behind the knee.

monies between the dances. The tortoise shell, too, is an instrument which has a weird, almost hypnotic tone. It is played by a man who squats on the ground with the shell gripped under the knee between thigh and calf muscles. Rapidly he rubs, almost jerks, the palm of his hand over the beeswax-coated head of the shell. Sometimes two men will play two tortoise shells and a pair of panpipes at the same time, and the continuous reverberation of the *goos*, as the tortoise shells are known, together with the syncopation of the panpipes produces an amazing effect. The high muffled tones of the *goos* echo round the *maloca*, driving the Indian's coca-bemused senses into a semi-hypnotic trance. To us this was not an unpleasant sensation and on listening closer we could pick out what was in fact a highly sophisticated rhythm. Each panpipe entered just off beat in an exciting, almost modernistic manner, more reminiscent of a modern jazz quartet than four primeval instruments of the Amazon.

Our recording equipment intrigued the Indians – those small boxes with wheels which turned, lengths of 'string' with weird metal objects on the end, held close to their faces or hung from the ridge poles of their *malocas*. It was all beyond their comprehension. At first they were frightened but once they had listened to their own voices and music, they were astounded and could not wait to hear more. We all too soon found ourselves using as much of our precious battery power to play back as we did to record. Sometimes

they were intrigued by Western music – Beethoven piano concertos, Brahms and Gershwin had little effect, but the Bach double violin concerto drew many eager faces, a Haydn trumpet concerto brought smiles of approval and on hearing the Commendatore's deep voice in the last act of *Don Giovanni* the whole *maloca* drew near in wonder. Perhaps this really was the white man's shaman.

We waited four days at Bréo's while the women brought in baskets and baskets of manioc to prepare for *chicha*, and the men pounded coca leaves incessantly. During this time the *maloca* filled with families who had travelled by canoe from their distant forest homes along the winding river courses. Some had already been warned by messengers of the coming festival to celebrate the manioc harvest, but on the afternoon before it started Bréo left for a high knoll of ground, and stood blowing a clay horn – perhaps to warn the people that the festival would start that night. The low booms rang out across the forest like blasts on a ship's foghorn. To the south, near the Caquetá, giant wooden drums were slung on a slant from two central poles of the *maloca* and beaten in a secret code as warning signals to other members of the tribe. The *mangwaré* drums were the jungle telegraph of Amazonia and their signals could be heard over twenty miles away.

The amount of time it takes for the festival to be prepared depends on the amount of *chicha* to be consumed. With over a hundred people present, four days were barely enough for the manioc roots to be rubbed down, the poisonous juice extracted and then boiled to form the basis of *chicha*. The starch sediment was baked over the clay ovens into giant wafer-thin biscuits. The boiling liquid was poured into the long *chicha* canoe which lay on the floor between two of the central posts; the toasted cassavas were broken into the liquid and fermentation began. The *chicha* gained rapidly in potency and the canoe was covered with an exquisitely woven cane mat like Japanese lattice. One ceremonial canoe was not enough, and another was brought from the river to be filled with yet more fermenting *chicha*.

In the evening the men sat chewing cocaine. Led by the shaman they consulted the spirits and their subdued mumblings continued far into the night. Their crouched bodies, lit only by the flickering of the resinous *turi* torchwood, reminded us of the semi-human rock carvings of their ancestors.

The *chicha* had fermented, the coca was prepared, the *maloca* was now a seething mass of people. The afternoon before the festival began, Wanina and the shaman's wife began to paint the bodies of the men. First deep red *karayuru* was smeared down the front of the torso, the thighs and along each arm with firm strokes of the fingers. A black liquid, the boiled juice from the leaves of a tree growing in their *chagras*, was painted on to the body with a three-pronged piece of cane. The hands and feet were totally blackened to above the wrists and ankles, and the arms and legs patterned with a lattice of diagonal lines. Then the women painted their own faces with *karayuru* and blackened their hands and feet.

As the sun's last rays filtered into the *maloca* and the mumblings of the council of elders died down, the shaman left the dark interior and stood in front of the men's doorway. In his hand he carried the *Kurubeti*, the sacred pebble stave. Intricate circles of blue and purple humming-bird feathers adorned one end, a swollen spearhead formed the other. This swelling was produced by soaking a bulge in the wood in water, then inserting this into a

banana stem and heating the spearhead over a fire. The swollen wood is cut open and three pebbles are inserted. During cooling the wood shrinks and the pebbles are locked in the cavity. The shaman stood pointing the stave away from the *maloca*. He hit it with his right hand and the stave swayed from side to side in front of his body. The rattling of the pebbles prevented the evil spirits from entering the *maloca*. In the days of tribal war, we were told, among the people living further to the south, each warrior carried one of these staves and after victory would dance himself into a frenzy, beating the stave against his shoulder.

With darkness the festival began. Bréo carefully rolled back the cane mat from the *chicha* canoe and the women handed round gourd after gourd, full of the bitter drink. More and more *chicha* was handed round to groups of people sitting contentedly by their family fires. Some of the younger men began to play their panpipes, but as yet there was no cohesion; the groups seemed rather to be competing with one another and different tunes came from all sides, one drowning the other. Many of these men had put sprigs of sweet-smelling leaves under their loin-cloth strings and berry arm-bands. The scent from the leaves was curiously sensuous, like sweet lemon, and used as an elixir of love by the Tukano during their festivals.

The same confused cacophony of dancing and panpipes continued well into the night; it was the young men's duty to keep the shaman awake, for not once during the course of the festival was he allowed to sleep. Small groups moved up and down the *maloca*, joyfully playing their panpipes as they danced, then they retired to their family fires and drank more *chicha*. The shaman remained apart, sitting on his stool in the centre of the *maloca*, gazing as if in a trance. At his side lay a calabash of coca and the sacred pot of *yajé*, the most powerful narcotic used by Amazonian Indians. Prepared from the boiled juices of a jungle creeper, the red liquid gives the shaman hallucinations and he is able to predict the future progress of the festival. Suddenly he summoned Bréo to his side. All the men came to the centre of the *maloca* carrying their wooden stools and sat down near him. With heads bent low the men started a muffled chant, answering in unison the solo monotone of the shaman. At intervals the coca calabash passed from hand to hand and each man threw a deer-bone spoon of the sage-green powder into his mouth. He stored it in his cheek and gradually the coca, mixed with saliva, filtered down his throat. Louder and louder, faster and faster became the chanting, echoing between the walls of the vast dark interior. The shaman worked himself into a frenzy, waving his arms out in front of him, his hands moving in wild gesticulations, his voice a rapid series of falsetto monotones; he was expelling all evil spirits from the tribal precincts to the heads of the *caños* and to other lands. The incantations continued for nearly two hours and then in the early hours of the morning there was silence.

The time had arrived for Bréo to unlock the precious box of plumages and he lowered it to the floor. He unwrapped the barkcloth cover and took off the lid of the beautifully woven palm box. Item by item he distributed the contents to the waiting figures, eagerly clambering to adorn themselves. First the smaller boys were given their simple crowns of red and yellow macaw and toucan tail-feathers, and they dashed away to adjust these on their heads. Underneath lay monkey-fur belts, ancient quartz pendants, puma-tooth necklaces and the most important items of all, magnificent feather head-dresses. These Bréo carefully selected and gave to the elders of the tribe. Crowns of toucan feathers woven on *cumare* frames adorned their

Palmleaf box with lid, of the type used for storing feather ornaments and other precious dance regalia between festive gatherings. Brazil.

(*opposite*) Makuna (Tukano) headman of the lower Piraparaná, Colombia. He holds part of a ceremonial headdress made of royal crane feathers. Before a dance the feather ornaments, which are much prized possessions, are taken from the palm-leaf boxes where they are stored between festivals and distributed to the male dancers.

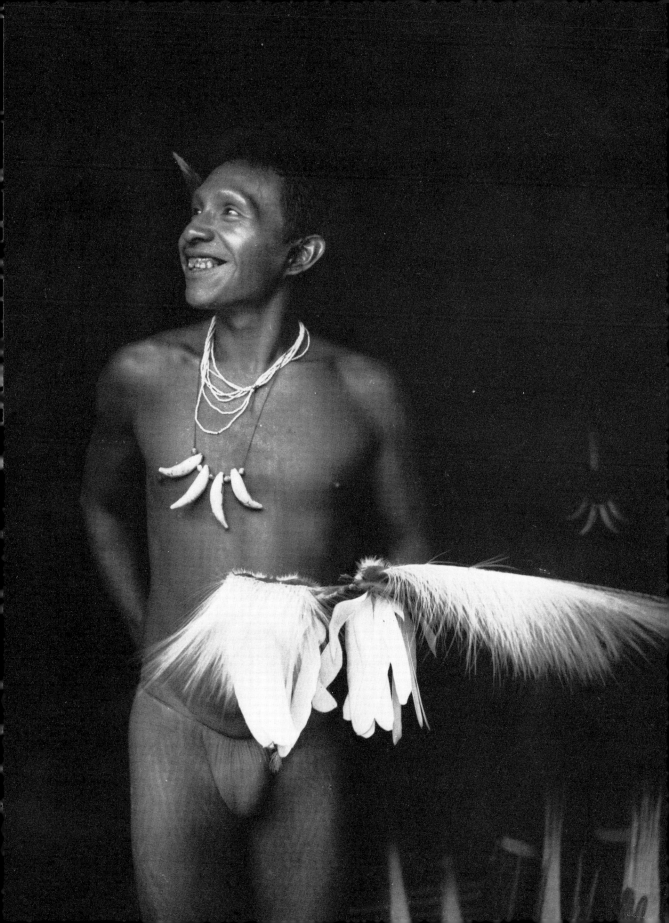

heads, brilliant gold and red, ringed with white duck-down. Majestic royal crane plumage, stuck into a banana stem which projected down the back, jutted vertically up from the back of the head. The white feathers were woven together in a *cumare* mesh and stood out like quivering spindles of spun glass, gleaming in the darkness. Behind was a single red macaw tail-feather, a deer bone bound to the banana stem with monkey fur and last of all the wing plumage of an egret.

Many of the men wore giant quartz obelisks dangling from their necks. They make them no more, but their ancestors used to spend days rubbing down large chunks of quartz in pebbleworn channels in the river beds. Others had necklaces of wild boars' tusks, pointing concentrically outwards. There were many monkey-fur armlets with glistening beetle wings which jingled as the men moved. Around the waist was another belt of monkey fur with puma teeth attached; below the knees finely-woven *cumare* garters, rubbed yellow with river clay, and above the right ankle dried *watcha* nut rattles. This, with the fierce red facial paint and black body design, made up the splendid dancing regalia of the Tukano. The women had no adornments; south of the Caquetá they stuck rings of white duck-down to their ankles with mud, but here they only painted their faces and bodies.

Now the dancing proper began. Since it was the manioc festival only the ceremonial *Nahubasa*, signifying the complete cycle of manioc from the time it was planted to the time it became cassava, was danced. Each man carried a long cane stave in his right hand and they joined in a line across the centre of the *maloca*, facing the women's quarters. Dazed from the *chicha* and coca they gazed in front of them and sang a slow dirge, beating their staves on the ground. Slowly they moved off in a clockwise circle inside the four central posts. The tempo increased, but the chant remained the same, the voices grew louder and combined with the hollow thuds from the staves and castanet-like rattles. The whole atmosphere changed, no longer were there rival groups competing with their neighbours, instead everyone took part in the dance. The women joined in, slipping their small bodies under the linked arms of the moving men. The circle increased, the women with their right hand to the small of the back of one man, and their left to the hip of another. Only Wanina, the headman's wife, accompanied by her small children and carrying Bréo's youngest son under her arm, did not join the circle. She moved slowly round the centre, her eyes fixed constantly to the ground, uttering a high-pitched wail as the dancers moved solemnly about her.

The manioc dance continued through the night, but with the approach of dawn the younger members became impatient for a change of rhythm. To them such festivals were an opportunity for amusement, heavy drinking bouts and the possibility of finding a wife. One or two started to play on their panpipes, they were joined by others and soon the whole *maloca* became alive with young couples and trios weaving happily across the floor, in between the posts and along the sides of the house. Their young bodies gliding through the darkness, their feet delicately stamping the time on the ground, they seemed completely lost in the lovely panpipe tunes of the *chiruru*, the Tukano courtship dance. All too soon the thuds of the bamboo staves were heard and the elders again took control.

Throughout the entire festival the dominating figure was the shaman. Existing as he does in complete detachment from the rest, he sat alone, occasionally taking snuff from his snail-shell box. It was he who influenced

the festival which, without him, would not take place. Every few hours he summoned the elders about him and as coca was passed round the mysterious chanting began. No one would tell us what was being recited, we could only gather that the tribal ancestors were being consulted and evil spirits exorcized. They did not like us to record this part of the ceremony, for quite understandably they believed we might take away their magic power.

Day and night the people danced, their plumed bodies glistening with sweat, caught in the beams of the sun or the dull glow of the torch-wood. There was continual sound – of panpipes, of cane staves, nutshell rattles and people's voices. Gradually the *chicha* canoes were drained. Gallons of the liquid had been consumed and the men had to rid themselves of their hangovers. Nonchalantly they poured boiled green-pepper juice down their nostrils from funnels made of leaves. With grunts and snorts they cleared their heads and staggered down to the river to bathe. Inside the *maloca* those that remained were asleep; many of the women had already left for the *chagra* and the visiting families began to leave. They moved quietly in single file down to their canoes, unleashed them and paddled away. Life returned to normal. The plumages stood in the sand, shimmering in the sun, before Bréo meticulously packed them away, and with them remained the memory of the dancing figures, resplendent as birds of paradise.

NOTES

1. The refined narcotic cocaine is a white crystalline alkaloid isolated from the leaves of the coca plant (*Erythroxylon coca*). The Tukano who chew powdered coca leaves receive only a small proportion of the active principal. Our use of the word 'cocaine' in its 'modern' context may therefore be misleading.

2. Although we witnessed and recorded musical instruments being played on numerous occasions and also saw a Karapana (Tukano) festival in the upper Piraparaná on our first journey, the description of the particular festival which follows, this literary contrivance notwithstanding, took place on our second journey in September 1961 to the Makuna (Tukano) of the Komeyaka, a tributary of the lower Piraparaná (see Tayler 1968: 37).

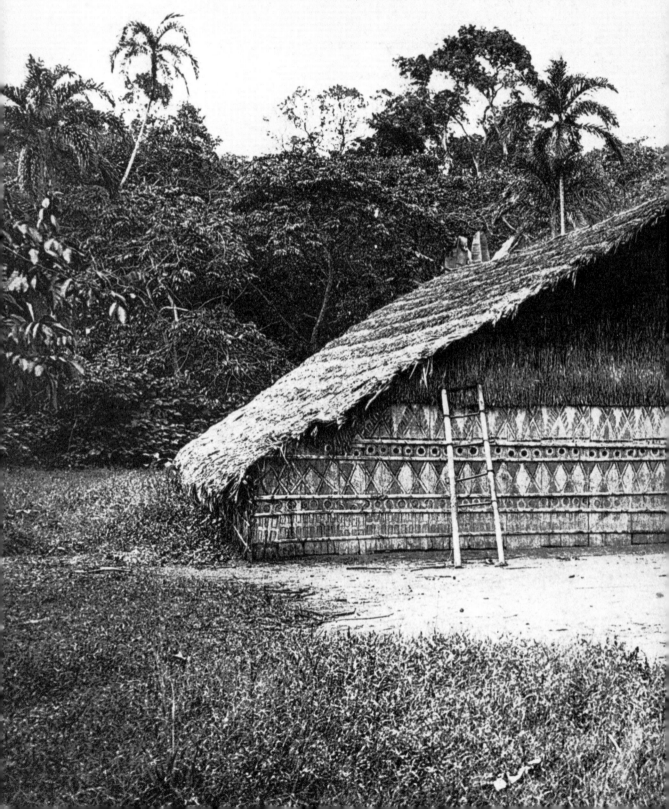

PART III *THE MALOCA:*
A WORLD IN A HOUSE

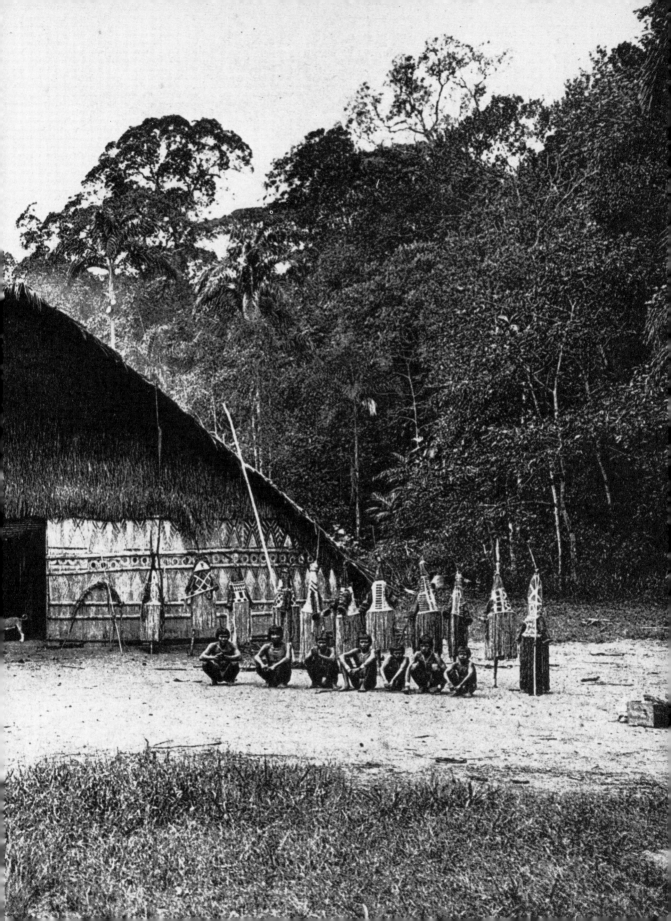

The Maloca: a world in a house

(previous page) A Cawa *maloca* or command house, Aiary river, north west Amazon.

The *maloca* or communal house is the characteristic dwelling of the Indians that live, or once lived, in the forests of Amazonia. These houses, often of immense size and holding up to one hundred and fifty people, serve a number of functions split between different buildings in our own society. For Indians, the *maloca* is the centre of the world and their lives. It serves as family home, kitchen and dining hall, workshop and storehouse, meeting place, club and dance hall, cemetery and temple and is a potent symbol representing the structure and divisions of society and model of the cosmos.

The Museum of Mankind exhibition, 'The Hidden Peoples of the Amazon' is centred on a partial reconstruction of a Barasana *maloca* in which objects of daily and ritual use are displayed. This essay is intended to set this material culture in its physical and social context and to provide an account of its use and social and symbolic significance. It refers in particular to the Barasana and their immediate neighbours (see map) but because of the overall similarity of Amazonian cultures in terms of subsistence, social organisation and symbolism, much of what is said applies elsewhere, at least in broad outline.

As one mark of their identity, each Amazonian tribe has its own style of architecture and even small variations in such things as the way in which roofing leaves are woven onto their supports often serve to mark off sub-

Map of north west Amazon showing location of tribes mentioned in text.

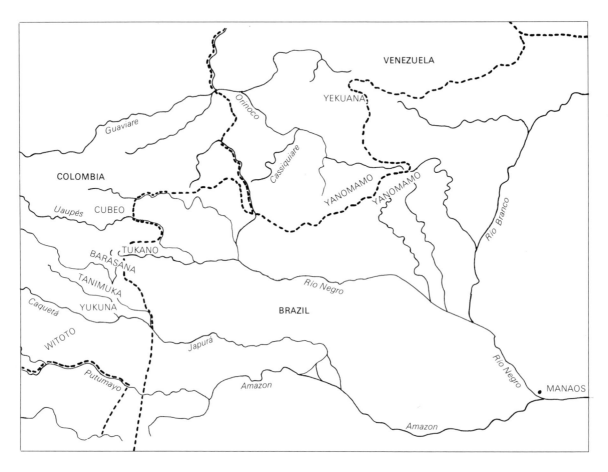

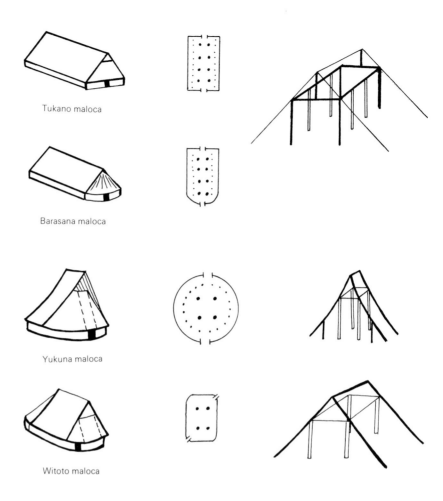

Figure 1 *Maloca* architecture – variations on a theme.

Tukano maloca

Barasana maloca

Yukuna maloca

Witoto maloca

divisions within a group. Many of these architectural differences can be shown to be variations on a common theme. Thus, for example, the rectangular *malocas* of the Tukano, the oval *malocas* of the Witoto and the round *malocas* of the Yukana are all built around four central pillars supporting a tent-like thatched roof with the semi-circular apse of the Barasana *maloca* representing a transition between the Tukano and Yukuna styles (see figure 1). Similarly, the round house of the Ye'kuana and the various styles of Yanomamö *shabono* are all based on a common theme (see figure 2).

Barasana *malocas* are usually separated by one to three hours of travel by trail or canoe. They are built close to rivers and streams used for bathing, travel and as sources of food and water. The new house is built in the middle of a manioc garden and, as the manioc gets used up, the surrounds are cleared of logs and debris to form a clean, sandy patio. Round the edge, pupunha palms (*Gulielma gasipaes*) and other fruit trees are planted and the rear serves as a kitchen garden, experimental plot and place for growing tobacco, gourds, hallucinogenic drugs and magical plants used in hunting, fishing and shamanism. Old house sites are thus regularly visited as an important source of food. From the front of the house a wide, clear path leads to a port on the river where canoes are moored and where the men go to bathe; from the rear another path leads to a stream where the women bathe, wash clothes and pots and soak vegetables prior to cooking. Other

Figure 2 Ye'kuana and Yanamamo
architecture.

Round, covered maloca.
Yanomamö, Ye'kuana

Ground plan of section of shabono
with hammocks and hearth.

Conical shabono. Yanomamö

Open, continuous shelter shabono
Yanomamö

Side elevation of open shabono.

Shabono with discrete shelters.
Yanomamö

Shabono with discrete, gabled huts.
Yanomamö

Side elevation.

paths lead off to the *chagras* or manioc gardens and beyond them to the forest, to hunting trails and to neighbouring *malocas* (see figure 3).

The decision to build a new house is taken by the men and is an occasion for important social adjustments within the group. By an informal process of discussion one man emerges as the initiator and director of the new project and it is he who becomes the headman of the new *maloca*. At this stage, one or more men may decide to split off taking their families to form a new community. The number of men who agree to live and work with the prospective headman determines the size and social composition of the new household. The size of the *maloca*, some over 130 feet long and 40 feet high is an index of the prestige of the group and its leader.

Housebuilding is a man's task as it involves woodwork and large-scale gathering of materials in the forest both of which are male activities. The ground is cleared of logs, roots and stumps and a plan is then traced in the sand using vines to measure the proportions. The men then cut the main timbers and gather vines for lashing them together. Two rows of hardwood

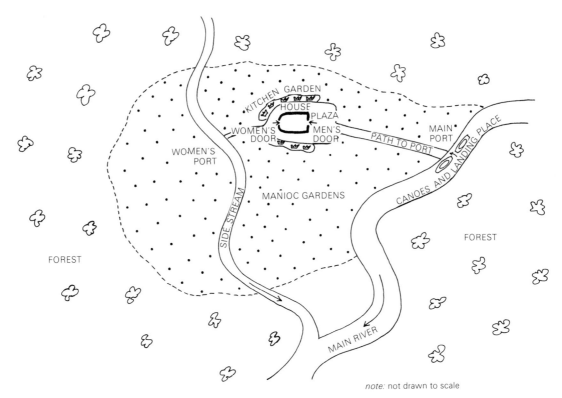

note: not drawn to scale

Figure 3 The *maloca* and its surrounds.

Figure 4 *Maloca* construction.

centre posts are sunk into the ground followed by smaller posts at each side. A ridgepole rests on small uprights standing on a central beam running the length of the house and supported by tenons across the main pillars. Other beams run along the tops of the side posts and across these, from the ridge almost to the ground, run long, thin poles which support strips of roofing leaves woven onto battens (figure 4). Roofing the house with palm leaves cut in the forest and carefully woven together may take two or three

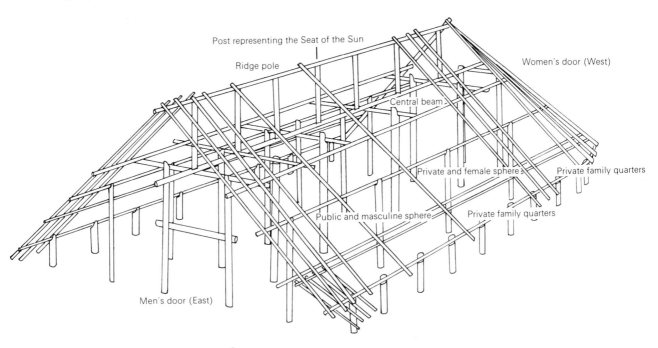

months and the household, fed up with camping in temporary shelters, usually moves into the half-covered house. The walls are closed gradually, often with strips of roof pillaged from the old house as energy and enthusiasm is often low by this stage. The more traditional and energetic households make the front wall of flattened sheets of bark which they paint with designs in chalk, ochre and charcoal representing dancers, spirits and visions induced by the hallucinogenic drug *yagé*.

The completion of housebuilding is marked by a big beer feast and dance to which neighbours, many of whom will have helped with the work, are invited. The house is likened to a human body and this housewarming gives it a heart in the form of its new inhabitants. The dance is also an occasion for shamans to blow spells to guarantee the strength and durability of the house and to protect it from wind, rain and lightning and other forms of mystical attack. After some ten to fifteen years and one or more replacements of the roof, repairs are no longer considered worthwhile and the *maloca* is abandoned, but the death of important members of the community often leads to abandonment of even quite new houses.

The tribes of northwest Amazonia, the Barasana and their neighbours, each claim ancestry from a different anaconda ancestor who brought them to the territory they now inhabit. Each group, whose membership is transmitted in the paternal line, is divided into a number of ranked clans each of which should ideally live together in the same *maloca*. In practice this rarely happens and the core of the *maloca* community is usually a group of brothers often living with one or both parents. These men recruit wives from other *malocas* and belonging to different tribes from their husbands; on marriage, their sisters go off to join their husbands in other houses. *Malocas* of four to six families and with fifteen to thirty inhabitants are typical of the region at present, though communities were much larger in the past.

Coming from the same clan and all of the same sex, the men form a solidarity group which is to some extent opposed to their in-married wives and the nuclear families which these women represent. This division is reflected in the way space is laid out and used. The house has a men's door at the front and a woman's door at the rear. Inside, the forward and central area is used by the men and is the focus of public ritual life, political affairs and the entertainment of guests. The rear and periphery is the province of women and the area of domestic and family life. These divisions are most marked during rituals, especially male initiation rites when women and children are excluded from the proceedings and confined in the rear of the house behind a screen of woven palm leaves. The front end of the house is also open and undivided whilst the rear sides are screened off into a series of compartments, one for each family (see figure 5).

The compartments, each with a door to the middle of the house and a small exit in the outer wall, are the focus of family life. Round a central hearth with three ceramic pot-stands on which pots of meat and fish are cooked, the family hammocks hang in a triangle. Above the fire hangs a rack on which meat, fish and other foods are smoked and where dried chilli peppers are stored in baskets and bark cloth bags. Leaning against the walls and stuck in the thatch are blowpipes, shotguns, bows, arrows, canoe paddles, fishing rods, nets, traps together with axes, *machetes* and other tools. Hanging from the roofs and on racks are baskets of *farinha* (toasted manioc meal), ripening bananas, plantains and pineapples and bundles of smoked meat, fish, ants and other foods. From stretched vines hang items of

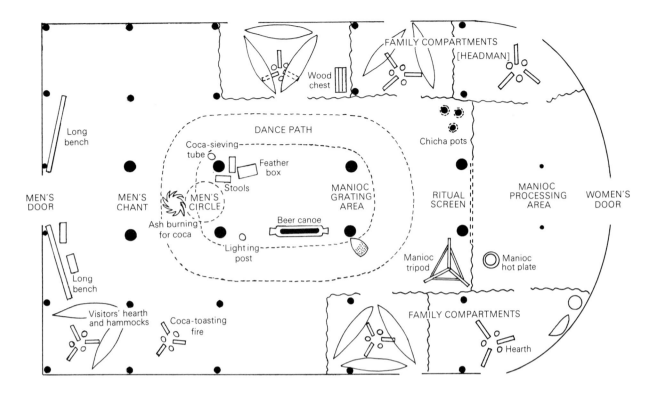

Figure 5 The *maloca* interior-grained plan.

clothing, blankets and bags, and round the edge, aluminium and ceramic pots, baskets and sieves are stored.

Men keep personal possessions, especially cloth, clothes, cartridges, shot and powder, knives, tools, beads, torches, radios and books all traded in from missionaries, rubber gatherers and cocaine dealers, in wooden chests made at carpentry courses run by local missions. Also stored are little bags of coca, which have had spells blown into them by the shamans at the birth of children which guarantee the child's health and well-being. Women keep their possessions such as face paint, mirrors, combs, sewing kit, stones for burnishing pots, medicines, half-made garters, beads and other items of jewellery in small baskets.

The open space at the rear of the house is used by the women for processing manioc. Woven manioc presses hang from the beams with a lever through a loop on the end of which the women sit to exert pressure. Nearby, on the floor, stands a huge ceramic hot-plate with a fire underneath used for cooking manioc bread. When not lit, the warm ashes are a favourite place for the household dogs to sleep. Next to this is a tripod stand used in washing manioc pulp and immense blackened pots for boiling roots and storing *chicha* (manioc beer). Each woman makes her own manioc bread which she places in a basket on a wicker stand outside the door of her compartment for everyone to eat. Meals are communal and served in the middle of the house, the men usually eating before the women and children.

In the middle and front of the house are items associated with men and with public, ceremonial life. Between two centre posts lies a canoe-like trough for *chicha* and opposite it, grouped round a post is the equipment used for the preparation and consumption of coca and tobacco. Next to this post lie wooden stools on which the men sit in a circle at night talking, smoking and chewing coca. They often weave baskets or roll string for

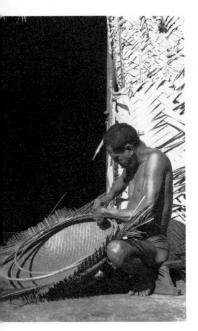

Man making a basketry tray for sifting manioc. He is seated upon a wooden stool of the type made and used by men. If they do not go off to fish or hunt, the men will stay near the house and work at making baskets, hunting-weapons or repairs to the house. Tukano, Colombia.

hammocks as they talk and behind them, towards the rear, the women sit in a semi-circle on low stools or palm-leaf mats. Light comes from burning vegetable pitch or long wooden tapers placed on a special post in the middle.

The centre of the house is sacred space and here the men are buried at death, women being buried just outside their compartments. From a beam above the centre hangs a finely woven palm leaf chest containing feather headdresses and ornaments used in dancing, together with eagle feathers ancient cigars, snuff, and other paraphernalia associated with shamanism. More feathers, rattles and musical instruments hang from branched sticks lashed to the forward houseposts. High up in the rafters, under the smoke-blackened roof, maize cobs are slung across the beams ready for cooking or for next year's planting. Along the front inner wall lie long, low wooden benches where visitors are received and sit together at dances. Outside lies a mortar for the preparation of *yagé* and under the eaves hangs the brightly painted *yagé* pot.

The open spaces at the sides of the house towards the front are especially reserved for visitors who come to stay and their position, equivalent but opposed to the family compartments in the rear, emphasises the outsider status of guests. Like gender and household membership, differences in age are also marked in space. Unmarried men sleep in the open front of the house, a position which also marks their slightly marginal status as not yet fully adult members of the group. As they marry, they build new compartments next to their elder brothers, the oldest brother, ideally the headman, having his compartment at the rear of the house on the right-hand side. The area round the four centre posts, the 'dance path', is used for dancing, and here too age and space are linked. In the middle of a line of dancers are the eldest men, renowned dancers and singers, with young boys learning the ropes at each end near the edges of the house.

In summary, we can now see that the space in the house is organised by two combined principles; front versus back and centre versus periphery onto which are mapped important social categories. In different contexts, the following divisions are all mapped in this way: male/female, elder/younger, married/unmarried, insider/outsider, host/guest, community/family, communal/individual, public/private, asexual/sexual, ritual/secular, consumption/production, cooked food/raw food. Though the details vary, principles such as these, mapped onto space underlie the organisation of all Amazonian *malocas* and it is these which order the disposition of objects in space and which lend to them a heightened significance.

As most food is shared and eaten communally, the *maloca* is a unit of consumption whilst production is centred on the nuclear family unit often working in cooperation with others. Clearing and burning the forest is done by men but thereafter most agricultural work falls to the women. The underbush is cleared with *machetes* and the bigger trees felled with axes, once of stone but now of steel. To save energy, smaller trees are cut half through and then toppled by a large tree felled at the top of a slope. The dead trees are left to dry out and then burned towards the end of the dry season in January or February. The women plant manioc cuttings in the ashes using *machetes* as digging sticks and interplanting with sugar cane, bananas, chilli peppers, fruit trees, cashew nuts, and other crops. Maize and *pupunha* are the only food crops grown by men but across the gardens they plant neat rows of coca bushes and patches of tobacco, *yagé* and fish-poison vines.

The staple diet, manioc, is provided by the women but supplemented by

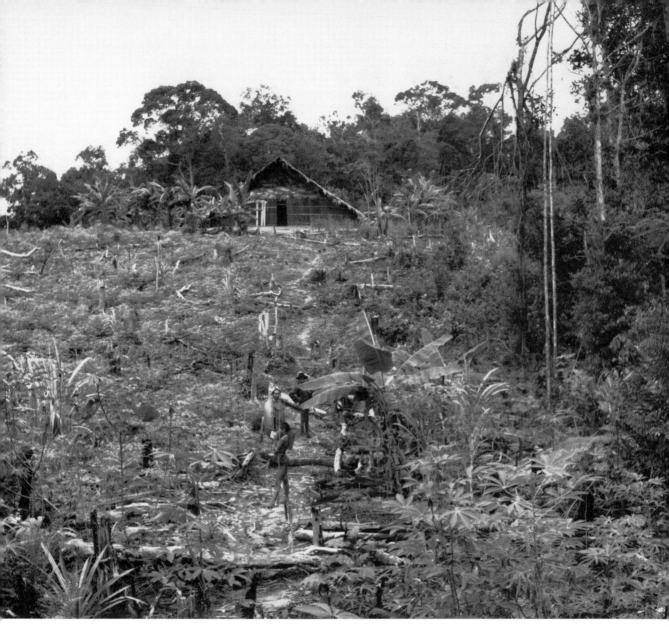

A manioc plantation below a Tukano *maloca*. The crops are planted between the remains of the felled and burned tree trunks. Banana trees are planted close to the house. Colombia.

meat and fish from the men and no meal is considered complete without a contribution from each sex. Bows, arrows, spears and blowpipes with poisoned darts kept in wicker cases are still used for hunting but becoming increasingly displaced by imported shotguns. Torches are another important piece of hunting equipment used to dazzle caymans and *paca* (a large rodent) at night. The young of many animals are kept as pets and houses have resident populations of macaws and other birds including chickens which for Indians are as exotic as parrots are for ourselves. Dogs are also kept and greatly treasured though most are rather inept at hunting.

Game, especially tapir, peccary, monkeys and wild turkeys, is the most esteemed food but the bulk of the protein comes from fish. Fish are caught in traps, stunned with poison, speared with harpoons, chopped with machetes and shot with bow and arrow but most are caught with imported hooks and nylon line. Canoes, made from logs hollowed out with large chisels and opened out after burning with fire, play an important role in fishing and the

One of the large basketry trays used for washing and sieving manioc pulp. Tukano, Colombia.

Barasana are expert canoemen used to the dangerous, rapid-choked rivers.

Much food is also gathered in the forest by both sexes though men always organise large scale gathering projects. In addition to palm nuts and forest fruits, the focus of elaborate ritual festivals, insects such as ants, termites, caterpillars and palm grubs along with many species of frogs all make up an important part of the total diet. Women and children armed with axes and sieves often go off together to the forest, on holiday-like expeditions where they cut palm hearts and catch shrimps and small fish in banks of leaves at the water's edge. Fish poisoning is a collective affair with a festive atmosphere. A weir of palm leaves, set with conical traps, is built across the river. Upstream, men beat poison vines, rinsing the milky, foaming juice into the water and stirring up mud with their feet. Downstream, women and children scoop up the stunned fish in nets and sieves while men spear the larger fish with arrows and harpoons.

Nearly all cooking is done by women. They carry home heavy loads of manioc tubers in vine or wood splint baskets slung from a bast band round the forehead and dump them in the stream to wash. The tubers are grated on a curved wooden board set with tiny quartz-chip teeth, the women sitting together round one housepost to do this work. The resulting pulp is placed in a large fine basketry sieve supported on a tripod, and water, poured onto the pulp, is squeezed through into a pot below carrying with it the tapioca starch and poisonous juice. The washed mash is then squeezed in a press, not, as commonly supposed, to remove the poison but simply to dry the pulp. Measured quantities of dried mash and starch are then mixed together and heated on the hotplate to form flat round cakes of manioc bread some two feet in diameter. These are turned with a fish-shaped woven turner, cut into quarters with a piece of broken canoe paddle and placed in a basket ready for use.

The poisonous juice is poured into a wide rimmed pot and boiled to drive off the prussic acid, leaving a nutty tasting drink which is cooled and served at dusk. Boiled further till caramelised, the juice makes a marmite-like dip served at breakfast. The toasted pulp of a special variety of manioc, left to soften in water and stirred with a paddle on the hot plate, makes a dry granular meal, *farinha* which stores well, is eaten on journeys and traded extensively throughout Amazonia. Manioc flour, boiled with water and flavoured with pineapple or banana, makes a refreshing soup-like drink. Meat and fish are usually boiled with lots of chilli peppers, served on a cut banana leaf or enamel plate and eaten with manioc bread dipped in the hot juice. Large quantities of fish and meat are smoked on racks over the fire and when properly dried will keep for long periods.

The gathering and processing of manioc is a long and arduous process which takes up most of a woman's day. The men's counterpart is coca processing to which they devote much time and effort. Coca leaves are picked, one by one, and carried home in a basket together with leaves from a fruit tree (*Pouronma cecropiaefolia*). The coca is toasted in a round-bellied pot and stirred with a vine hoop till dry and brittle. It is then pounded in a mortar and mixed ash from the other leaves burned in a pile on the floor of the house. The powdered mixture is put in a bark-cloth bag, tied to a long stick and pounded against the sides of a long hollow balsa cylinder. The dust-like green powder is tipped out into a bowl and distributed between various gourds, storage pots, bark bags and tins. It is passed round in a gourd and eaten off a tapir bone scoop.

Woman peeling and trimming manioc tubers using a *machete*. They will then be carried to the river to be washed. Tukano, Colombia.

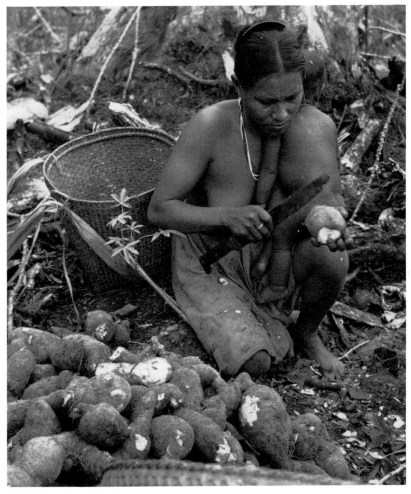

Makuna woman making a pottery vessel. The clay is coiled and the walls of the vessel are thinned with the hand and a piece of gourd or fruit rind. Here the potter is working on a low wooden stool of the kind used by men in the *maloca*. The little boy is wearing ligatures below the knee. These are put on in infancy and continue in use in adult life to emphasise the shape of the calf muscles.

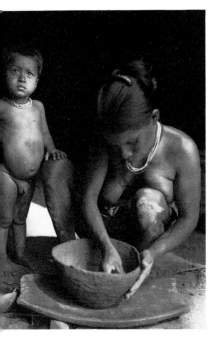

Coca chewing takes place in a slightly formal atmosphere and is accompanied by snuff and cigars. Tobacco leaves, heated to a mush on a piece of broken pot, are pressed into bark formers and dried by a fire. Bits are broken from the lump, dried on a small ceramic plate and stuffed into a long banana leaf cigar which is passed around with the coca gourd. In the past, beautifully carved cigar holders, with a pointed end to stick in the ground, were used. Held upside down with the cigar in position, the holder represents a man with the cigar as his penis, a secret reference to a major creation myth. Snuff, made from tobacco leaves and ash in a process like that for coca, is stored in snail shell or gourd containers and taken through ingenious V-shaped snuffers or long bone tubes. Coca, snuff and cigars, together with *yagé* and *chicha* form a class of 'anti-foods' usually taken by men and at night and never mixed with normal food which is eaten before sundown.

The division of labour, manifest in subsistence activities, also emerges in handicrafts. Pottery, using clay tempered with burned tree-bark ash, is made by women. Pots are made by coiling and then burnished with polished pebbles, treasured possessions passed from mother to daughter. After firing, pots are smoked over a smudge fire which gives them a black glaze. *Yagé* pots are then painted by the men with designs which represent the visions produced by the drug. Men also decorate pot trumpets with incised lines filled with chalk. Gourds for storage, food and drink are also

prepared by women. Scraped clean, the inside is coated with a red tree sap; when left over manioc leaves mixed with urine, the sap is reduced to a strong black glaze.

Basketry, including sieves, manioc presses and blowpipe dart cases, is made by men from the rind of a species of cane (*Ichnosiphon*) and boys are systematically taught the different techniques involved as part of their initiation into adult life. Men also make blowpipes, bows, arrows, canoes, paddles, stools, troughs, mortars and pestles and other objects of wood. They also make all objects for ritual such as musical instruments, feather headdresses, staffs and clubs. Women make face and body paints and weave garters from knotted string made of wild pineapple fibre.

Like space, clothing and ornament distinguish categories of sex, age and social occasion. Young babies wear nothing but tooth necklaces, glass bead bracelets and spots of sticky red paint on their faces to ward off mystical dangers. They are carried in barkcloth slings worn over the shoulder, or placed in baby-bouncers hung from the roof beams and positioned just out of reach of their mothers' work. Young girls wear simple cotton skirts of brightly patterned trade cloth and their hair is allowed to grow till puberty when it is all cut off. Older women wear home-made cotton dresses with characteristic short puffed sleeves. The hair is worn long and held in place with curved plastic combs in bright colours. Strings of glass beads, white for preference, and cheap metal earrings complete the attire.

Boys and men wear their hair cut short but, in the past, adult men wore long hair in a bound *queue* down their backs. Men's dress consists of a small cotton g-string now usually worn below shorts or trousers with a shirt on top. Watches, leather belts and baseball caps advertising outboard motors are favoured by the younger men. On their arms, men wear lizard skin bracelets and arm-bands of shiny black palm nuts with beads and Catholic saint pendants round their necks. In their ears they have small cane ear plugs and, in the past, a lip plug was worn as well. Small rubberised cloth bags containing combs, mirrors, paint, hunting and fishing gear, files, matches, tobacco, snuff, garters, whistles and palm leaf boxes of treasures are worn on a string over the shoulder.

Both sexes paint their faces with a red powder obtained as a sediment from the boiled leaves of a vine (*Bignonia chica*). This paint, an important article of trade, is stored in bark cloth bags and in carved palm nuts with a wooden stopper. It is applied with a wax-tipped stick and oil on the face, encouraged by the application of chilli pepper juice, makes the paint stand out. Women also painted themselves with *urucu* seeds (*Bixa orellana*) and accentuate the hair and jaw lines with a black dye obtained from another leaf. For dances, this same dye is used to stain feet and knees black and to trace basket-weave patterns on the legs and arms using twig brushes or roller stamps. The men also wear ochre-stained garters with red and yellow toucan feather tassles to accentuate the calf muscles.

At dances, this basic costume is enhanced with a variety of other ornaments. A fully dressed dancer wears white bast round the ankles and a string of seed rattles above the right foot. Round the waist is a belt of jaguar or pig teeth or rose-coloured shell supporting a crimped and painted bark cloth apron hanging in front with sprigs of aromatic leaves tucked in over the buttocks. On the right elbow is a monkey-fur bracelet with feathers, snail shells and metallic-coloured beetle wing-cases as jingling pendants. Round the neck hangs a heavy cylinder of white quartz on a necklace of

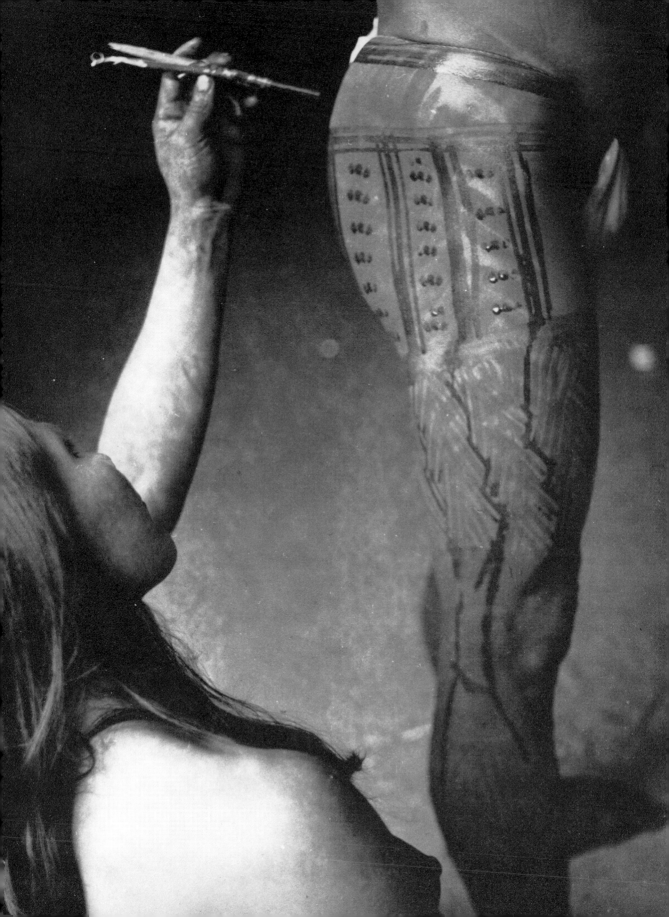

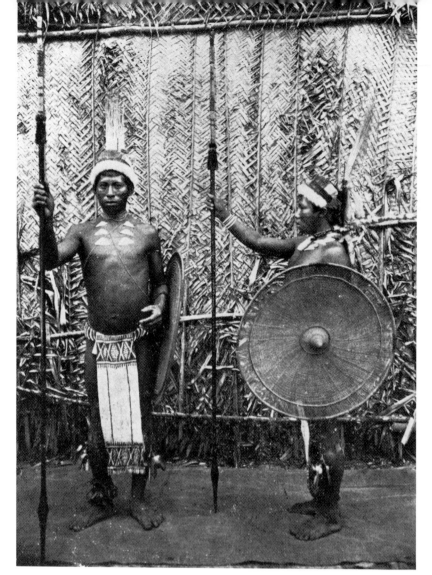

Two Tukano dancers carrying wicker shields and rattle staves. This photograph was taken in 1903–5 and, apart from the shields having become obsolete, the regalia of these dancers is the same as that worn by the dancers photographed in the 1960s by Brian Moser and Donald Tayler.

black seeds with another necklace of jaguar teeth and silver metal triangles on top. Sections of polished brass cartridge case hang from the ears and a wide band of macaw feathers is worn across the forehead. To obtain the feathers, pet macaws are plucked of their feathers and plant juices are rubbed on the skin causing the new feathers to take on a deep yellow colour. A band round the head supports a banana leaf stalk at the back, a substitute for the old pigtail of hair bound with monkey-fur string. Into this are stuck a plume of white egret feathers on a woven frame, a red macaw tail with white streamers and a stick of down with a green feather topping. Onto the stalk is bound a hollow jaguar or eagle leg-bone and from this hang hanks of monkey-fur string, white egret wings or fish-shaped objects with a mosaic of brilliant blue and purple cotinga feathers. White hand-kerchiefs and towels often complete this attire. In the past, shields of woven vine and ceremonial adzes were also carried and elaborate combs worn in the hair but sadly today these items are found only in museum collections. Other simpler headdresses consist of a woven palm-leaf crown with a sun-burst of red and yellow feathers, edged with a red and yellow feather band and sometimes topped with dollops of white down.

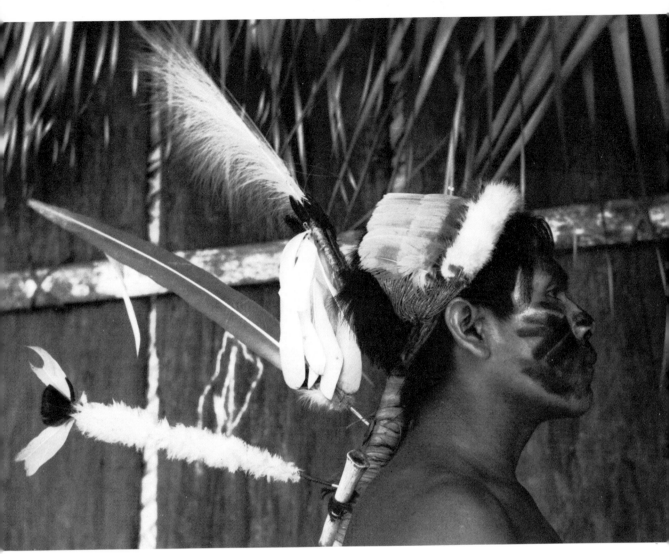

Full Tukano ceremonial headdress consisting of a gold and red toucan-feather band edged with down; a comb topped with royal crane feathers; a macaw feather and a deer bone attached to the banana-stem 'queue' with a monkey-fur string. The final ornament is of egret wing feathers.

The Makuna, Tanimuka and Yukuna, southern neighbours of the Barasana, use masks of painted balsa and painted pitch on a wicker frame at elaborate festivals connected with the *pupunha* palm harvest. The Barasana used to wear painted bark-cloth masks representing animals, birds, fish and other spirits which came to welcome the souls of the dead at funeral ceremonies and their neighbours the Cubeo still make and use these masks today.

Until the turn of the century, the Barasana engaged in feuding and raiding with their neighbours with women and feather goods as prizes. The main weapons were clubs, spears and poison-tipped javelins with tapir-skin shields for defence and poison-tipped daggers for close combat. Today warfare has ceased and inter-community relations are mediated through beer feasts, dances and ceremonial exchanges of food and treasured feather goods together with the exchange of women in marriage.

Each kind of festival has its own appropriate set of dances, songs and accompanying musical instruments together with special varieties of beer. At food exchanges, the transactions are announced with blasts on pottery trumpets and the dancers dance with hollow tubes of bamboo or painted

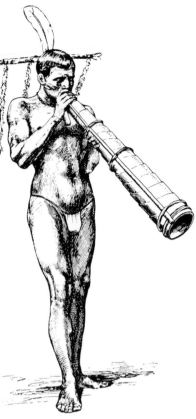

Tuyuka man of the Tiquié river playing a Yurupary bark trumpet.

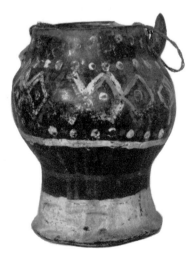

Painted pottery vessel of the type used for *yagé*, an intoxicant produced from the bark of the vine *Banisteriopsis caapi*. The drink is used, especially by shaman, to produce the visions which put men in touch with the world of the spirit ancestors.

balsa thumped rhythmically on the ground. At forest fruit festivals, large quantities of palm and other fruits are brought into the house to the sound of bark-wrapped megaphone trumpets and thick palm wood flutes called *Yurupary* which women and children are forbidden to see. At the dance which follows this maracas are always used. A similar festival involving palm grubs and caterpillars requires the use of ghostly-sounding piston-whistles in addition to the trumpets and flutes.

At initiation rites for young boys, more sacred and secret Yurupary instruments, with the flutes engraved and wrapped in yellow feather ruffs, are used and the initiates are whipped with whips made from peeled saplings. After a two-month seclusion in a compartment constructed by the men's door where they learn basketry, the boys are treated to a celebratory dance which announces their new status. A huge pile of cassava bread, wrapped in white leaves and topped with feathers, stands in the centre of the house and the dancers dance round it blowing cane flutes and holding jaguar bones wrapped in sun-burst ruffs of red and yellow feathers. During an interval, the dancers line up behind a man playing a deer-skull whistle and dance gingerly back and forth in imitation of the deer's movements. At the close of the proceedings, the pile of cassava bread is distributed and pieces, tied together with bast strips are thrown into the rafters where they hang in festoons.

Preparations for dances involve the making of vast amounts of *chicha*. Roots are boiled in a pot, fished out with a lacrosse-stick-like scoop and chewed by women and children. The resulting mash is mixed with boiled manioc juice and left to ferment in pots or in a large trough carefully covered and stood on warm ashes. The men prepare lots of coca and snuff and the dance is announced with blasts on pot trumpets which carry across the forest. In the past, huge painted wooden slit-gongs beaten with rubber-headed sticks were used to call the guests. As they arrive, the guests are greeted, served with large gourds of *chicha* which they must drain in one go and invited to sit. The dancers put on their headdresses and begin to dance, later joined by the women who tuck their heads under the shoulders of the men. At intervals in the dance the men, sit with guns, clubs and ceremonial staffs leaning on their shoulders in a circle in the centre of the house taking coca and tobacco and chanting myths of origin. *Yagé* vines are pounded in a mortar and the macerated bark is mixed with water, sieved and the bitter brown liquid put in the *yagé* pot. The *yagé* is then served in little gourd cups to each man by the officiating shaman. As the drug begins to take effect the men play on cane flutes and whistles made from snail shells and fruit seeds. Their sound is that of the *yagé* birds, spirits of the drug, that bring brightly coloured visions to the men.

As the dancers chant, the other men play choruses of panpipes and dance, weaving in and out between the posts of the house accompanied by the beating of drums. Tortoise carapaces with a lump of pitch at one end are rubbed with the hand to produce a rhythmical squeaky honk which accompanies a panpipe tune played on a single instrument. The middle of the night is announced by the shaman playing the rattle-lance. The lance, decorated with feather mosaic and with small pebbles inserted in a swelling at the end, is held in the right hand and hit with the left to produce a sustained rattle as it vibrates along its length. The dance continues till sunrise and after bathing in the river, the company sling hammocks all over the house and sleep off the effects of the previous night.

It is in the context of rituals that the *maloca* assumes its major significance as a cosmic symbol for at such times the house becomes one with the universe and spirit world it represents (see figure 6). The roof is the sky supported by the posts, which are mountains, with the walls representing the hills at the edge of the world. *Malocas* are orientated on an east-west axis with the men's door to the east and the women's door to the west. The ridgepole along the top is the path of the sun across the sky and a post above the centre of the house and centre of the world is his seat at midday. An imaginary river, flowing down the middle of the house from west to east

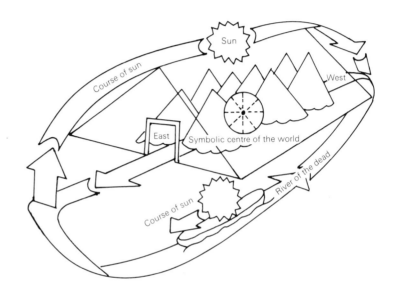

Figure 6 The *maloca* as cosmos.

represents the rivers of the earth that flow in this direction and below the floor runs the river of the dead, where the dead go after burial in canoes, flowing from east to west to complete the circuit. By day, the sun travels across the sky to set in the west where it travels up the underworld river in a canoe to rise again in the east. In this way space and time are brought together in one symbolic complex.

Symbol of cosmic space and of human society, the *maloca* also represents a human body. As a man, its painted front is a painted face with the door for a mouth, ridgepole for backbone, lateral beams for ribs and central river for gut. As a woman, with head to the rear, the men's door is her vagina and interior a womb which shelters and nourishes the people inside. Thus the body physical, the body social and the universe, micro-space and macro-space are all united in one potent symbol.

PHOTOGRAPHIC ACKNOWLEDGEMENTS

Unless otherwise stated, all the objects and photographs not credited below are from the Museum of Mankind (Department of Ethnography of the British Museum).
We would like to extend thanks to all who gave permission for their photographs to be used. Thanks should also go to Helen Wolfe for preparing the maps and diagrams, and to Donald Tayler for the drawing on the title page and cover.

David Attenborough 19, 21 (right), 25, 26 (below), 28 (above left)
Cambridge University Museum of Anthropology 34, 35
after H. A. Coudreau (1887) 33
after W. C. Farrabee (1917) 29
John Hemming Plate 1
after F. Keller-Leuzinger (1874) 9, 10, 11, 15, 21 (left)
after T. Koch-Grünberg (1909–10) 23, 55, 76–7, 90, 92
Brian Moser and Donald Tayler Collection 2–3, 20, 32, 38–9, 41, 42, 45, 46, 51, 53, 57, 59, 60, 61, 63, 64, 65, 68, 69, 70, 73, 84, 85, 86, 87, 89, 91 Plates 4, 5, 6, 7, 8
G. Polykrates and C. Søderberg 22, 34
Royal Anthropological Institute 30
after J. B. von Spix and C. F. P. von Martius (1831) 28 (below), 31, 36 (above), 37 (right)
after H. Staden (1557) 14, 24 (right), 26 (above)
after K. von der Steinen (1894) 27 (right)
Sandra Wellington 24 (left), Plate 2

BIBLIOGRAPHY

† Titles with particular relevance to Part II
* Titles with particular relevance to Part III

AGHOSTINHO, P., *Kwarip, Mito e ritual no Alto Xingú*, São Paulo, 1974

ÅRHEM, K., 'Fishing and hunting among the Makuna: Economy, ideology and ecological adaptation in the Northwest Amazon', *Göteborgs Etnografiska Museum Årstryck*, Gothenburg, 1976

ARHEM, K., 'Observations on life cycle rituals among the Makuna: Birth, initiation, death', *Göteborgs Etnografiska Museum Årstryck*, Gothenburg, 1980

ARHEM, K., 'Makuna Social Organization', *Uppsala Studies in Cultural Anthropology*, 4, Uppsala, 1981

AVENI, F. and URTON, G. (eds), 'Ethnoastronomy and Archaeoastronomy in the American Tropics', *Annals of the New York Academy of Sciences* 385, New York, 1982

BARBIRA-SCAZZOCHIO, F. (ed.), *Land, People and Planning in Contemporary Amazonia*, Cambridge, 1980

BARRETT, S. A., 'The Cayapa Indians of Ecuador', Part I, *Indian Notes and Monographs* 40, Museum of the American Indian, New York, 1925

BATES, H. W., *The Naturalist on the River Amazons*, London, 1864

BATES, M., *The Land and Wildlife of South America*, Hong Kong, 1980

BECKER-DONNER, E. *et al. Brasiliens Indianer*, Vienna

BERTHELS, D. E. KOMISSAROV, B. N., and LYSENKO, T. I., 'Materialen der Brasilien-Expedition 1821–1829 des Akademiemitgliedes Georg Heinrich Freiherr von Langsdorff', *Völkerkundlishe Abhandlungen*, 7, Berlin, 1979

BIOCCA, E., 'Viaggi tra gli Indi Alto Rio Negro – Alto Orinoco', *Appunti di un biologo*, Vol. I, Rome, 1965

BISSET, N. G., 'The Botany and Chemistry of Brazilian Arrow Poisons', Appendix to E. G. Heath and V. Chiara, *Brazilian Indian Archery*, qv.

BISSET, N. G. and HYLANDS, P. J., 'Cardiotonic Glycosides from the Latex of *Naucleopsis mello-barretoi* a Dart-Poison Plant from North-West Brazil', *Economic Botany*, 31, 3, 1977

BLIXEN, O. and KLAPPENBACH, M. A., 'Notas sobre tatuajes y pinturas de los Makiritare', *Museo de Historia Natural, Montevideo, Communicaciones antropologicas*, 1, 5, 1966

BOTTING, D., *Humboldt and the Cosmos*, London, 1973

BROMLEY, R. D. F. and R., 'South American Development: A Geographical Introduction', *Cambridge Topics in Geography*, 2nd Series, London, 1982

BRÜZZI ALVES DA SILVA, A., *A Civilização Indígena do Uaupes*, São Paulo, 1962

DE CAMPANA, D., 'L'arte Plumaria dei Mundurucú (Brasile) e di altri popoli del Sud-America', *Archivo per l'Antropologia et la Etnologia, Soc. Italiana d'Antropologia, Etnologia e Psicologia Comparata*, 35, Florence, 1905

CHAGNON, N. A., *Yanomamö: The Fierce People*, New York, 1968

CHIAPPELLI, F. (ed.), *First Images of America*, Berkeley, 1976

COUDREAU, H. A., 'Voyage à travers les Guyanes et l'Amazone', *La France equinoxiale*, Vol. 2, Paris, 1887

COWELL, A., *The Tribe that Hides from Man*, London, 1973

FARABEE, W. C., 'The Central Arawak', *Anthropological Publications*, Vol. IX, University Museum, Philadelphia, 1918

FARABEE, W. C., 'Indian Tribes of Eastern Peru'. *Papers of the Peabody Museum*, Vol. X, Cambridge, Massachusetts, 1922

FARABEE, W. C., 'The Central Caribs,' *Anthropological Publications*, Vol. X, Philadelphia, 1924

FERRARO DORTA, S. *et al.*, 'Arte Plumaria do Brasil', *Fundaçao Nacional Pró-Memória*, Brasilia, 1980

FOCK, N., 'Waiwai: Religion and Society of an Amazon Tribe', *Ethnographic Series*, Vol. 8, Copenhagen, 1963

DE LA FUENTE, F. R., *Animals of South America, World of Wildlife*, London, 1975

FURNEAUX, R., *The Amazon: the story of a great river*, London, 1969

FURST, P. T. (ed.), *Flesh of the Gods*, London, 1972

GEBHART-SAYER, A., *The Cosmos Encoiled: Indian Art of the Peruvian Amazon*, New York, 1984

GOLDMAN, I., 'Cosmological Beliefs of the Cubeo Indians', *Journal of American Folklore*, 53, 1940

GOLDMAN, I., *The Cubeo: Indians of the Northwest Amazon*, Champaign, 1963

GOLDMAN, I., 'The structure of ritual in the Northwest Amazon', in R. A. Manners (ed.), *Process and Pattern in Culture: Essays in Honor of Julian H. Steward*, Chicago, 1964

GOODALL, E. A., *Sketches of Amerindian Tribes, 1841–1843*, London, 1977

GOODMAN, E. J., *The Explorers of South America*, New York, 1972

GROSS, D. (ed.), *Peoples and Cultures of Native South America*, New York, 1973

HAMES, R. B. and VICKERS, W. T. (eds). *Adaptive Responses of Native Amazonians, Studies in Anthropology*, New York, 1983

HARNER, M. J., *The Jivaro: People of the Sacred Waterfalls*, New York, 1972

HEATH, E. G. and CHIARA, V., *Brazilian Indian Archery*, Manchester, 1977

HEMMING, J., *Red Gold: The Conquest of the Brazilian Indians*, London, 1978

*HENLEY, P., *Amazon Indians*, London 1980

HENLEY, P., *The Panare*, New Haven, 1982

HOPPER, J. H. (ed.), *Indians of Brazil in the Twentieth Century*, Washington, 1967

*HUGH-JONES, C., *From the Milk River: Spatial and temporal processes in Northwest Amazonia*, Cambridge, 1979

*HUGH-JONES, S., *A Closer Look at Amazonian Indians*, London, 1978

*HUGH-JONES, S., *The Palm and the Pleiades: Initiation and cosmology in Northwest Amazonia*, Cambridge, 1979

HUXLEY, F., *Affable Savages*, London, 1956

JACKSON, J. E., *The Fish People*, Cambridge, 1983

KARSTEN, R., *The Head-Hunters of Western Amazonas*, Helsingfors, 1935

KOCH-GRÜNBERG, T., *Zwei Jahre unter den Indianern: Reisen in Nordwest-Brasilien, 1903–5*, Berlin, 1910

KRAUSE, F., *In den Wildnessen Brasiliens*, Leipzig, 1911

KUMU, U. P. and KENHÍRI, T., *Antes o Mundo Não Existia*, São Paulo, 1980

LATHRAP, D., 'The "hunting" economies of the tropical forest zone of South America', in R. Lee and I. de Vere (eds), *Man the Hunter*, Chicago, 1968

LATHRAP, D., *The Upper Amazon, Ancient Peoples and Places*, London, 1970

LEE, B. T. and KEATON, H. C. (trans.), 'The Discovery of the Amazon', *American Geographical Society Special Publications*, 17, New York, 1934

DE LÉRY, J., *Histoire d'un voyage fait en la terre du Brésil*, La Rochelle, 1578

LYON, P. V., *Native South Americans: Ethnology of the least known continent*, Boston, 1974

MACCREAGH, G., *White Waters and Black*, New York, 1926

MAYBURY-LEWIS, D., *The Savage and the Innocent*, London, 1965

MAYBURY-LEWIS, D., *Akwé-Shavante Society*, Oxford, 1967

MAYBURY-LEWIS, D. (ed.), *Dialectical Societies: The Gê and Bororo of Central Brazil*, Cambridge, Massachusetts, 1979

MEGGERS, B. J., 'Some problems of cultural adaptation in Amazonia', in B. Meggers, E. S. Ayensu and W. D. Duckworth (eds), *Tropical Forest Ecosystems in Africa and South America*, Washington, D.C., 1973

MÉTRAUX, A., 'La Civilization matérielle des tribus Tupi-Guarani,' *Bib. de l'école des hautes études sciences religieuses*, 45, Paris, 1928

MORISON, S. E., *The European Discovery of America*, New York, 1974

†MOSER, B. and TAYLER, D., 'Tribes of the Piraparana', *The Geographical Journal*, 129, 4, London, 1963

†MOSER, B. and TAYLER, D., *The Cocaine Eaters*, London, 1965

†MOSER, B. and TAYLER, D., 'We sought the music of the river tribes', *Children's Britannica Yearbook*, London, 1962

MURPHY, Y. and MURPHY, R., *Women of the Forest*, New York, 1974

ODELL, P. R., and PRESTON, D., *Economies and Societies in Latin America: A geographical interpretation*,

O'LEARY, T. J., 'Ethnographic Bibliography of South America', *Human Relations Area Files*, New Haven, 1963

PARRY, J. H., *The Discovery of South America*, London, 1979

PIGORINI MUSEUM, *Indios del Brasile*, Rome, 1983

REICHEL-DOLMATOFF, G., *Amazonian Cosmos*, Chicago, 1971

REICHEL-DOLMATOFF, G., *The Shaman and the Jaguar*, Philadelphia, 1975

REICHEL-DOLMATOFF, G., *Beyond the Milky Way*, Los Angeles, 1978

RIVIÈRE, P. (ed.), 'Amazania Orinoco and Pampas', *Peoples of the Earth*, 6, 1973

ROOSEVELT, A. C., *Parmana: Prehistoric maize and manioc subsistence along the Amazon and Orinoco*, New York, 1980

ROTH, W. E., 'An inquiry into the animism and folk-lore of the Guiana Indians', *30th Annual Report, Bureau of American Ethnology, 1908-9*, Washington, 1915

ROTH, W. E. (trans.), *Richard Schomburgk's Travels in British Guiana, 1840-1844*, Georgetown, 1922-3

ROTH, W. E., 'An introductory study of the arts, crafts and customs of the Guiana Indians', *38th Annual Report, Bureau of American Ethnology, 1916-17*, Washington, 1924

ROTH, W. E., 'Additional Studies of the arts, crafts and customs of the Guiana Indians,' *Bulletin 91, Bureau of American Ethnology*, Washington, 1929

SAUER, C. O., *The Early Spanish Main*, Cambridge, 1966

SCHOEPF, D., 'Essai sur la plumasserie des Indiens Kayapo, Wayana et Urubu, Bresil', *Bulletin Annuel, 14, Musée d'Ethnographie*, Geneva, 1971

SCHOEPF, D., *La Marmite Wayana, cuisine et societé d'une tribu d'Amazonie, Musée d'Ethnographie*, Geneva, 1979

SCHULTES, R. E., and HOFMAN, A., *Plants of the Gods: origins of hallucinogenic use*, London, 1980

SCHULTHESS, E., *The Amazon*, London, 1963

SEEGER, A., *Nature and Society in Central Brazil: The Suya Indians of the Mato Grosso*, Cambridge, Massachusetts, 1981

SILVERWOOD-COPE, P., *A contribution to the ethnography of the Colombian Makú*, PhD dissertation, Cambridge, 1972

SISKIND, J., *To Hunt in the Morning*, Oxford, 1973

VON SPIX, J. B. and VON MARTIUS, C. F. P., *Travels in Brazil in the years 1817-1824*, London, 1824

SPRUCE, R. (ed. A. R. Wallace), *Notes of a Botanist on the Amazon and Andes*, London, 1908

VON DEN STEINEN, K., *Unter der Naturvölken Zentral-Brasiliens*, Berlin, 1894

STERLING, T., *The Amazon, The World's Wild Places*, Amsterdam, 1973

STEWARD, J. H. (ed.), *Handbook of South American Indians*, Vols 1-7, Washington, D.C., 1946-59

STEWARD, J. H., and FARON, L. C., *Native Peoples of South America*, New York, 1959

STREIFF, R., 'Litjoko – Poupée Karaja (Bresil)', *Bulletin Annuel, 9, Musée d'Ethnographie*, Geneva, 1966

†TAYLER, D., 'Tropical forest people of south-eastern Colombia', *Recorded Sound*, No. 31, London, 1968

†TAYLER, D., 'The Music of some Indian tribes of Colombia, (texts and records based on the Moser-Tayler collection)', *B.I.R.S.*, London, 1972

TESSMAN, G., *Menschen ohne Gott*, Stuttart, 1928

TESSMAN, G., *Die Indianer Nordost-Perus*, Hamburg, 1930

THEVET, F. A., *Les Singulariteis de la France Antartique*, Paris, 1558

IM THURN, E. F., *Among the Indians of Guiana*, London, 1883

TRUPP, F., *Die Letzten Indianer*, Wörgl, 1981

TURNER, T. S., 'Tchikrin: a Central Brazilian tribe and its symbolic language of bodily adornment', *Natural History*, 78, 8, Washington D.C., 1969

VELLARD, J., *Histoire du Curare*, Paris, 1965

WAGLEY, C., *Welcome of Tears: the Tapirapé Indians of Central Brazil*, Oxford, 1977

WALLACE, A. R., *Travels on the Amazon and Rio Negro*, London, 1889

WATERTON, C., *Wanderings in South America*, London, 1828

WELLINGTON, S. I., *The Art of the Brazilian Indians*, London, 1978

WHIFFEN, T., *The North-West Amazons*, London, 1915

WHITTEN, N. E., *Sacha Runa: Ethnicity and adaptation of Ecuadorian Jungle Quichua*, Champaign, 1976

WINKLER, H., *Campa-Indianer*, Munich, 1978